A PIECE OF MY HEART

PEDACITO DE MI CORAZÓN

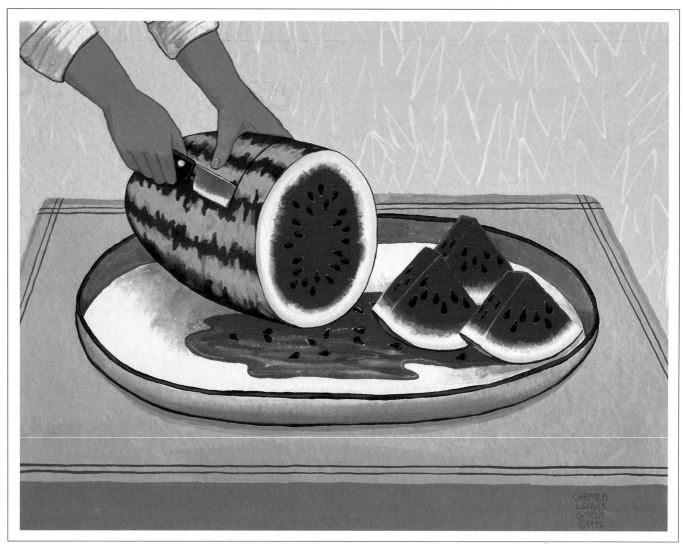

Sandía/Pedacito de mi Corazón (Watermelon/Little Piece of My Heart), 1986, gouache, 11 1/2 x 15 inches, Collection of Richard Duardo, Los Angeles, CA

A PIECE OF MY HEART / PEDACITO DE MI CORAZÓN
THE ART OF CARMEN LOMAS GARZA

CARMEN LOMAS GARZA
WITH AN INTRODUCTION BY AMALIA MESA-BAINS

The New Press, New York

Published in association with the Laguna Gloria Art Museum, Austin, Texas

Detail: *Tzintzuntzan (Land of Hummingbirds),* 1988, black paper cutout, 25 1/2 x 19 1/2 inches, Collection of the artist

This book was previously published in slightly different form as an exhibition catalog by Laguna Gloria Art Museum, Austin, Texas, in 1991. Major support for the exhibition and catalog was provided by the National Endowment for the Arts and the Texas Commission on the Arts.

Published in the United States by The New Press, New York
Distributed by W. W. Norton & Company, Inc., 500 Fifth Avenue,
New York, NY 10110

ISBN 1-56584-164-6

Established in 1990 as a major alternative to the large, commercial publishing houses, The New Press is the first full-scale nonprofit American book publisher outside of the university presses. The Press is operated editorially in the public interest, rather than for private gain; it is committed to publishing in innovative ways works of educational, cultural, and community value that, despite their intellectual merits, might not normally be "commercially" viable. The New Press's editorial offices are located at the City University of New York.

Laguna Gloria Art Museum is funded in part by the City of Austin under the auspices of the Austin Arts Commission, the Texas Commission on the Arts, the National Endowment for the Arts, a federal agency, the Women's Art Guild, and the members of Laguna Gloria Art Museum.

Production by Kim Waymer

Printed in the United States of America

9 8 7 6 5 4 3 2

C O N T E N T S

EMPOWERING THE FAMILIAR — A FOREWORD

By Daniel E. Stetson, Executive Director

Detail: **A Medio Día Como Los Camaleones (At High Noon Like the Lizards),** 1988, black paper cutout, 25 1/2 x 19 1/2 inches, Collection of the artist

he artworks of Carmen Lomas Garza explore the many roles of the *familia* from within the artist's personal experience. This gift of remembrance strikes a familiar bell of understanding within each of us. The ability to enter this world view is greatly enhanced by the gentle style that belies a deep seriousness found within these works.

Each of these paintings, prints, paper cut-outs and altars is a gift from the artist of a world view that proffers understanding. Sharing a memory, so empowered, transforms the everyday into potent narrative. The genre scenes are as enlightening in their clarity as the spiritually charged works are in their allegory.

Dr. Amalia Mesa-Bains' deep-felt essay affords a great deal of insight concerning the cultural-political environment that imbues these artworks. This sense of engaged history motivates the artist and draws the viewers into a world both familiar and unknowably personal. In addition to Peter Mears' curatorial selection of works, eight full-color illustrations have been added. This ordering shares the stages of life and memory as it is revealed in the artworks of Carmen Lomas Garza.

This book honors what is universal, and what is individual, within experience. We each have remembrances of family that will give perspective to the act of viewing. These works are a very special gift from Lomas Garza to the community of humankind. Each of us is empowered by the circle of our understanding and we are equally enriched when we share our view. This book shares the view—literally the vision of the eyes and the mind—of a Chicano artist with all who pause to share in the excellence of the objects and spaces rendered. We each can explore the corners, tabletops, flora and fauna of scenes of domestic action and discover for ourselves the values implied in their ordering.

To partake in the experience of the *other* is to celebrate an intimacy that brings each of us closer to a shared understanding. The affection found in Lomas Garza's art does not reflect a sentimentality but rather a depth that is unaffected. Honesty of this kind, in a world full of illusions, is a rare and special gift. These artworks are a call to remember our roots, and to truly respect each others'.

ACKNOWLEDGMENTS

It is an unfortunate fact that the "life expectancy" of an exhibition catalog is too often connected to the life span of the exhibition upon which it is based, especially if the response to the exhibition is overwhelmingly successful. Thus, when we were presented with an opportunity to revive and expand the catalog for *Pedacito de mi Corazón*, the exhibition that was the genesis for this book, we were excited that Carmen Lomas Garza's work might reach an even broader audience. This opportunity was particularly welcomed as the popular and critical reception to Lomas Garza's work caused our catalog edition to sell out completely. Therefore, through the exceptional efforts of The New Press, it is with great pleasure and pride that we now have this opportunity to present *Pedacito de mi Corazón* once again.

The paintings, prints, and ceremonial constructions that follow offer us poetic recollections of Carmen Lomas Garza's childhood memories of rural Kingsville, Texas. Through the positive depiction of everyday family events and the cultural practices of her community, Lomas Garza, who now resides in San Francisco, continues to pay homage to the land of her origin and the heritage of its people.

This publication would not have been possible without the generous support of all those who contributed to *Pedacito de mi Corazón*. Their generosity reflects a genuine affection and commitment that a growing number of people have for the artist and her work. My thanks are also due to the Laguna Gloria Art Museum's hardworking and highly creative staff. My special appreciation goes to Amalia Mesa-Bains, nationally known artist, writer, and scholar of Latino art, who has written a superb essay that not only explores with great sensitivity the development and direction of Lomas Garza's art, but also provides an excellent overview and analysis of the creative impulses found in the production of Chicano art and the cultural sources that inspire it.

I remain deeply grateful to the National Endowment for the Arts and the Texas Commission on the Arts for funding the exhibition and catalog. Their contributions acknowledge the quality of Carmen Lomas Garza's work and the importance of making it available to as wide an audience as possible.

Finally, I extend my deepest regards and appreciation to Carmen Lomas Garza for her exceptional commitment to this latest publication of *Pedacito de mi Corazón*. I congratulate her on this moving and deeply meaningful body of work, and am grateful for her sharing with us those memorable days well-lived and well-remembered in Texas.

Peter Mears, Curator of Exhibitions
Laguna Gloria Art Museum, Austin, Texas

CONTRIBUTORS TO PEDACITO DE MI CORAZÓN

Marina D. Alvarado & Gilbert Mercado Jr., *Los Angeles, CA*

Steven Alvarado and Catalina Guevara Alvarado, *Oakland, CA*

Richard L. Bains & Amalia Mesa-Bains, *San Francisco, CA*

Paula Maciel Benecke & Norbert Benecke, *Soquel, CA*

Robert Berman/B-1 Gallery, *Santa Monica, CA*

Dudley Brooks, *Seattle, WA*

Gilberto Cardenas and Deanna Rodriguez, *Austin, TX*

Antonia Castañeda and Arturo Madrid, *Claremont, CA*

Anna Chavez and Richard Fineo, *San Francisco, CA*

Teofila Dane, *San Francisco, CA*

Don Ramon's Restaurant, *San Francisco, CA*

Richard Duardo, *Los Angeles, CA*

Galería Sin Fronteras, *Austin, TX*

Carmen Lomas Garza, *San Francisco, CA*

Ramón A. Gutiérrez, *San Diego, CA*

Nicólas and Christina Hernández Trust, *Pasadena, CA*

Sonia Saldivar-Hull and Felix Hull, *Austin, TX*

Pamela and Martin Krasney, *Sausalito, CA*

Jacqueline Markham, *West Hollywood, CA*

The Mexican Museum, *San Francisco, CA*

The Oakland Museum, *Oakland, CA*

Socorro Maria Pelayo, Esq., *San Francisco, CA*

Ira and Gail Schneider, *Scottsdale, AZ*

Sophie Fierro-Share and Daniel M. Share, *Birmingham, MI*

Calvin Taunton, *Los Angeles, CA*

Mary Ross Taylor, *Houston, TX*

Ann and Richard Tell, *Los Angeles, CA*

A PIECE OF MY HEART / PEDACITO DE MI CORAZÓN

By Carmen Lomas Garza

Detail: ***Nopalitos (Cactus),*** 1979, white paper cutout, 8 1/2 x 14 inches, Collection of the artist

When I was five years old my brother came home crying from the first grade in public school on the third day of classes because the teacher had punished him for speaking Spanish. She had made him hold out his hands, palms down, and then hit him with a ruler across the top of his hands.

This confused us because up to that day my parents had been telling us about how much fun we were going to have in school. So we looked to them for an explanation of this confusing reaction over such a natural act as speaking and why he deserved the unusual punishment. The expression on my parents' faces and their mute silence haunts me to this day. It must have been such a painful moment for them. How could they explain that the punishment was for racial and political reasons and not because he had done something bad?

The incident and the punishment caused much discussion among my parents, their friends and peers whose children were also experiencing the same treatment. Even though it had been seven years since my father and other Mexican Americans had returned from military service during World War II, things had not changed very much in Texas. Now that their children (the baby boom generation) were becoming school age, the discrimination continued. It did not matter that some of our families had been *Tejanos* (Texans) since the days of the Spanish land grants — long before Texas was taken from Mexico. Nor did it matter that almost all of us were *mestizos*, a mixture of Spanish and native Mexican or native American.

Discrimination against the Mexican American was the main reason my parents became involved with the American GI Forum, a World War II Veterans' organization of Mexican Americans who fought for civil rights. One of their first activities was to sue a funeral home for refusing to receive the body of a Mexican American hero killed in the Korean War.

My brother's incident still had to be explained. My parents tried to tell us the reasons for the punishment and stressed that from then on at home we would practice speaking only in English and not both languages as we had been doing. I did not make <u>nor</u> understand the distinction between the two languages. And my parents many times spoke in both languages in spite of their decision. All I kept thinking was that I was next in line to go to school the following year.

When I finally did get to school, my first grade teacher was a bit more compassionate and actually took the time to explain the fact that <u>the</u> Spanish and <u>the</u> English we spoke were not all one language. She demonstrated this by bringing from her bedroom to the classroom a huge fluffy pillow with colorful embroidery and said that the name we knew for it, *almohada,* was Spanish and *pillow* was English. <u>I knew and used both words</u>.

The realization that the pillow had a written name <u>and</u> that I knew two languages clicked in my mind just like it had for Helen Keller when she understood the connection between the sign word in her hand for water and the actual water that was falling on her hand. But what had been one world was now two separate entities and it seemed that I had to negate one in order to be accepted and exist in the other.

Knowing the difference between the two languages did not save me from unconsciously using Spanish in the classrooms and

on the school grounds so I, too, suffered many physical and emotional punishments. Each time I spoke English I was ridiculed for my accent and made to feel ashamed. At a time when most children start to realize that there is an immense outside world, and communication is an important vehicle toward becoming a part of that world, the educational institution was punishing me for speaking two languages.

When I was in junior high school I complained to my mother:

> *"Mami, ya no quiero llevar tacos de tortilla de harina con arroz, frijoles y carne para lonche porque se rien las gringas."*

> ("Mami, I don't want to take tacos of flour tortillas with rice, beans and meat for lunch because the white girls make fun of me.")

Tacos that were nutritious and made with love, care and hope had to be replaced with sandwiches of baloney and white bread.

In high school we could take Latin, French or Spanish classes but the Mexican American students were still not allowed to speak Spanish in the halls or in other classrooms. It was so ironic to see the white students practicing their new Spanish words and phrases while walking down the halls yet the Mexican American students could expect punishment for doing the same. But the punishment wasn't with a 12-inch ruler across your hands; it was with a 30-inch paddle that had holes drilled into it so that there would be less air resistance as it was slapped across the back of your legs. By the time I graduated from high school I was confused, depressed, introverted and quite angry.

The Chicano Movement for civil rights of the late sixties and early seventies clarified some of that confusion, started the slow process of self-healing and provided a format to vent some of that anger. I had decided at the age of 13 to become an artist so when I was in college the Chicano Movement nourished that goal and gave me back my voice.

But the university art department (which had over 50% Chicano students, the highest compared to all the other departments) did not offer art history classes about my heritage: neither pre-Columbian, colonial or contemporary Mexican; nor the native American art, even though we were sitting in the middle of South Texas only 120 miles from the Mexican border. Instead we learned about French Rococo and Henry Moore, the English sculptor. I knew more about the Egyptian pyramids than the pyramids in Teotihuacan. I knew more about Greek mythology than Aztec mythology. The only source for formal training about my heritage was in the anthropology department but only after the study of the bones and teeth of Leaky's Lucy.

I was looking for information about the Aztecas, Toltecas, Apaches and Hopi; the Nahuatl language and poetry; the Mayan ceramic sculptures; the gold jewelry and surgical obsidian knives; cultivation of corn, chocolate, cotton, and the vulcanization of rubber. It would have been real cool when I was in high school to have known that way before Columbus invaded this hemisphere the Maya were playing a form of basketball wearing open-toe high top tennis shoes with rubber soles.

Discussions with the other Chicano students were the best source of information. It was during one of these discussions, in which I described my revelation with the word pillow, that someone commented that the word *almohada* was of Arab origin as were many other words in the Spanish language.

How does a 6 year-old child in South Texas in 1954 come to use a word from halfway across the world for such a beautiful and intimate object? A word that traveled from a desert across a channel, up and down mountains, across an ocean, over and around islands, through jungles and up to another desert. The history of that word's journey as carried by thousands of people from parent to child, generation after generation had been suppressed or ignored by the two institutions of education that I had already experienced.

And so the anger, the pride and self-healing had to come out as Chicano art--an art that was criticized by the faculty and white students as being too political, not universal, not hard-edge, not pop art, not abstract, not avant-garde, too figurative, too colorful, too folksy, too primitive, blah, blah, blah!

What they failed to see was that the art I was creating functioned in the same way as the *salvila* (aloe vera) plant when its cool liquid is applied to a burn or an abrasion. It helped to heal the wounds inflicted by discrimination and racism.

We needed to heal ourselves and each other so we started by choosing a name for ourselves, a name to symbolize our movements for self-determination. The accomplishments of our parents during the 50's civil rights movement were not enough. We started to speak more Spanish in public places; we worked to get better representation on school boards and local governments, and we started to explore and emphasize our unique culture in the visual arts, music, literature and theater.

I felt that I had to start with my earliest recollections of my life and validate each event or incident by depicting it in a visual format. I needed to re-celebrate each special event or re-examine each unusual happening.

We have been doing Chicano art not only for Chicanos but also for <u>others</u> to see who we are as people. If you see my heart and humanity through my art then hopefully you will not exclude me from rightfully participating in this society.

Aquí les doy un pedacito de mi corazón en mi arte.
And now I give you a little piece of my heart in my art.

CARMEN LOMAS GARZA

The original draft of this paper was presented at a multicultural symposium at the San Francisco Art Institute in 1990 called <u>Contextual Symposium: A Challenge to Institutions</u>.

CHICANO CHRONICLE AND COSMOLOGY:

THE WORKS OF CARMEN LOMAS GARZA

By Amalia Mesa-Bains

Detail: *Paper Flowers,* 1988, black paper cutout, 18 x 20 inches, Courtesy of the artist and Galeria Sín Fronteras

The recognition of Chicano and Latino art contributions to a larger American aesthetic has brought with it interest in the work of particular artists. Carmen Lomas Garza is, in this sense, a key figure in understanding the visual representations of Chicano culture. Her *monitos* or little people paintings are an important body of work that has served as an alternative chronicle of communal, familial, historical and cultural practices. In her role as a chronicler she maintains a tradition beginning with the first generation of *mestizaje Cronistas* of the New World. Lomas Garza develops her genealogies and lays claim to her origin and the origin of the Chicano community. Like these first *cronistas* caught in a catastrophic moment of history she (re)members for us as an act of resistance. The sense of another chronos or time is Lomas Garza's device for memory and resistance. As an alternative chronicler her history is a response to the institutional Texas histories of the Alamo and the Texas Rangers.

In the most socio-political sense Lomas Garza's use of memory stands against the historical erasure of Chicano culture. She remembers what we can never forget and thereby subverts the dominance of an Anglo society. Her chronicle tells a story of the everyday, the regional, the rural and the personal. The *loteria* game, the *cumpleaños* (birthday party), the cakewalk gathering and the faith healing of the *curandera* accumulate in her narrative to create a cosmology of cultural values and identity. Within this world Lomas Garza, like all story tellers, provides us with characters, locations, times and moments of importance. These cultural narratives reflect the childhood of Lomas Garza in her Kingsville, Texas barrio and reflect historic

elements on both an intimate and personal plane. Yet the images of *Para La Cena (For Dinner)*, and *Curandera*, are part of the memories of a generation of rural Chicanos. The details of Lomas Garza's narratives are the signifiers of the collective that bind together an important regional Chicano experience. Along with Santa Barraza, another Texas painter, Lomas Garza has brought to a wider audience the remembrances of a rural Texas landscape of community pastimes like the *tamalada* (making tamales), the *feria (fair)* and the healing traditions of such important figures as Don Pedrito Jaramillo, a legendary south Texas faith-healer. In the creation of her faithful Chicano visual vocabulary Lomas Garza has made familiar the characters in a setting often tinged with an atmosphere where the details hint at dangers which can only be warded off by the protectiveness of the family. She is a textural weaver who leaves gestures of both the familiar and the sinister. Both scholars Tomas Ybarra-Frausto and Victor Zamudio-Taylor have remarked on the disquieting aspects of wonderment and the mystery found in the paintings of Lomas Garza. Although the artist has remained true to the historiography of her life and her community, the tales depicted have larger allegorical references to death, aging, innocence, and faith.

ORIGIN

In a retrospective sense the twenty-year span of works by Carmen Lomas Garza has a point of departure —a beginning moment. This origin resembles a call and response. The call was most surely the Chicano Movement and the response, her *monitos* prints and

paintings. Coming of age in the Chicano Movement gave the artist a point of resistance to the years of discrimination, humiliation and pain so characteristic of life for Mexican-Americans in Texas.

Despite the political organizing of her parents in the American G.I. Forum, Lomas Garza was unprotected from the everyday brutalities of racism. The harsh repression of the Spanish language by teachers whose punishment brought confusion and bitterness could only be tolerated and balanced by the warmth of family and community life.

Carmen Lomas Garza, like many Chicano artists of her generation, traces her artistic lineage to the family and to the genesis of the Movement. The powerful political movement for Chicanos resisting the blatant racism of the United States occurred for the most part in the late 1960's and the early 1970's. Lomas Garza found herself on a college campus organizing with other Chicanos for *el movimiento* and trying to determine for herself how her art could serve her community and, even more importantly, how she could find a future and meaning for her life as an artist. Surveying her future beyond college, with few available jobs in art, Lomas Garza struggled with a sense of anger and hopelessness.

It was in this moment that the artist recognized the opportunity for a new direction. Following the Mexican American Youth Organization (MAYO) conference in Texas in 1969, Lomas Garza began to develop a renewed sense of purpose. In that period her dark renderings of fetuses were reflections of a groping for life, and of dreams stillborn. Amidst this difficult time the artist recognized not simply the resistance and rage so well articulated in Chicano posters and murals, but the first vestiges of affirmation. In the years of 1969 and 1970, Carmen Lomas Garza began to formulate and enunciate the philosophy that would drive her work for more than 20 years and would continue to have meaning into present time. She recognized that while the men who dominated the movement were earnestly and passionately depicting the violent and oppressive conditions of Chicanos, there was an absence of the positive and vibrant images of her *cultura*. It was in this recognition that the artist determined to give something back to the community. She determined to (re)call, (re)mind and instruct her fellow Chicanos of the loving and truly collective nature of their lives.

Beginning with her own family and community traditions she committed herself to producing art work that records and reflects the beauty of Chicano culture. This recalling from childhood, she believed, would create something with which other Chicanos could identify. In a sense, Carmen Lomas Garza was establishing a combination of resistance and affirmation, a kind of Chicano self-recovery. Like the catalyst for Black self-recovery articulated by Bell Hooks,

> *"We need to keep alive the memory of our struggles against racism so that we can concretely chart how far we have come and where we want to go, recalling those places, those times and those people that gave a sense of direction".*[1]

And so the artist made her *compromiso* (promise) to her community; charting the places, the times and the people who gave her a sense of direction. From this point, she decided to begin with the

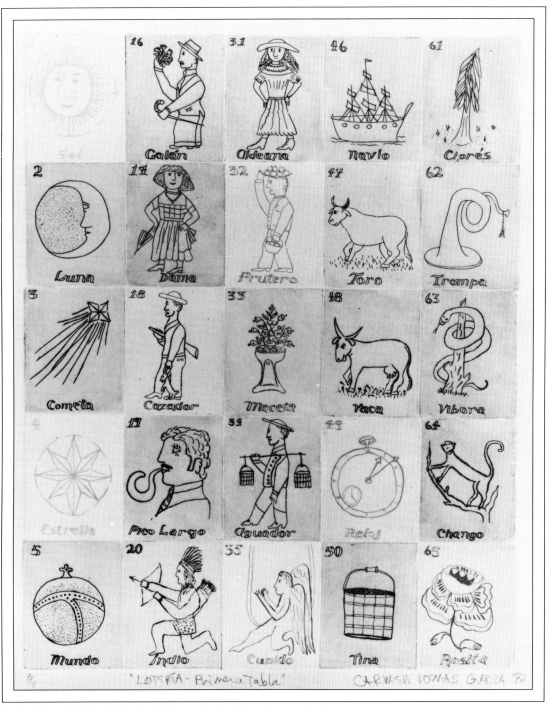

Loteria - Primera Tabla (First Playing Card), 1972, color etching, 12 x 10 inches, Collection of the artist

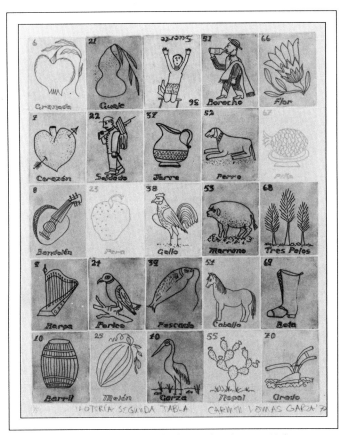

Loteria - Segunda Tabla (Second Playing Card), 1972, color etching, 12 x 10 inches,
Collection of the artist

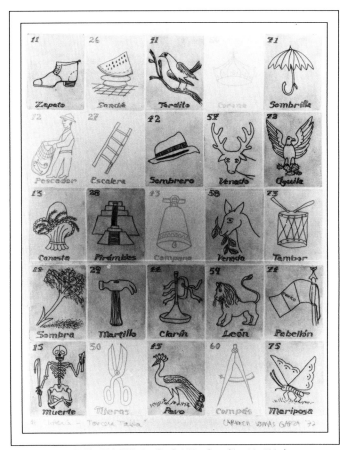

Loteria - Tercera Tabla (Third Playing Card), 1972, color etching, 12 x 10 inches,
Collection of the artist

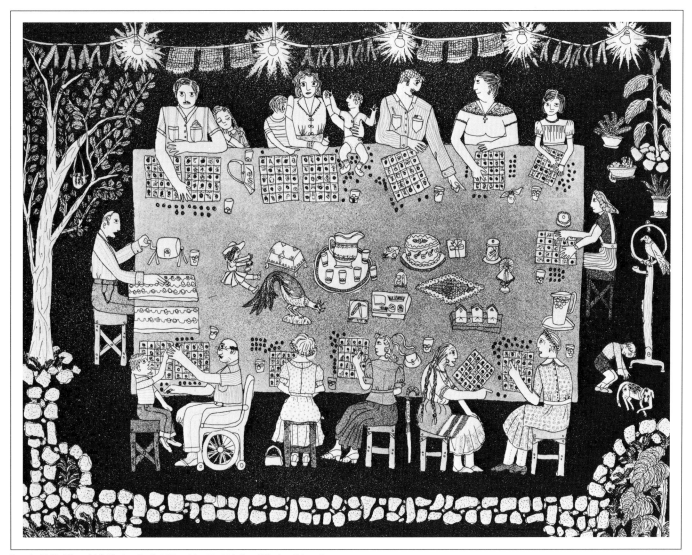

Loteria, Tabla Llena (Full Playing Card), 1972, etching, 14 x 18 inches, Collection of the artist

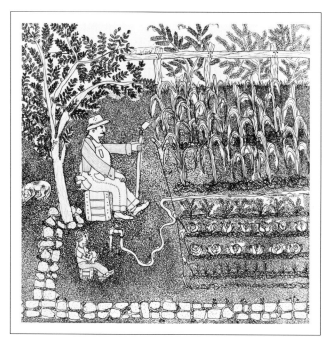

Jardín (Garden), 1972, etching 10 x 10 inches, Collection of the artist

primary influence on her own young artistic self—her mother. She had long been intrigued by the traditional *loteria tablas* (playing cards) images painted by her mother and passed down by others in her community. True to Chicano thinking she decided to begin with the innovation or invention of a new Chicano *loteria*. Perceiving the *loteria's* seventy five images as a cosmology of cultural meanings, Lomas Garza decided to do the Chicano version. Taking advantage of the *pochismo* or Spanish words used by many Chicanos, she aimed to create a *loteria* composed of images such as *la llanta* (the tire), *el aeroplano* (the airplane), and *la troca* (the truck). But such inventions were not to be the case as her mother counseled her to recall the old *loteria* first before she began the new. Consequently in 1971 Carmen Lomas Garza began a faithful rendering of the flattened figures and symbolic cultural instruction of the *loteria tablas* and the famous *monitos* were born.

Like a creation myth, her *monitos,* little dolls or little people, began to narrate the everyday collective experiences and beliefs of the Chicano culture. They are part of a primary cultural reclamation that has come to represent a cultural cosmology. Through this cosmology the artist has observed, documented, organized and depicted the Chicano worldview.

The *Loteria Tablas* (1972) were the beginning of the long process of charting the Chicano cultural cosmos. Lomas Garza has been like the caller seated at the end of the *loteria* game, with her stories faithfully registering the everyday. As the images appear, provoked by the caller's rhyme we can instantly remember the *tabla, cumpleaños, tamalada,* or *posada* (Christmas procession).

With her jokes, riddles, and enigmas, she makes us search for every clue, detailed and quietly hidden in her careful arrangements. Like the *loteria* cosmology of images grouped by categories such as celestial and earthly; *la estrella* (the star), *el sol* (the sun), *la muerte* (death), the *monitos* paintings signify an *estilo* Chicano (Chicano style) of gatherings, events, practices and traditions characteristic of her cosmos.

She began her first work after the *Loteria Tablas* (1972) with an etching whose subject was personally and collectively significant in *Jardín (Garden)*. The cherished relationship with her grandfather is a part of her claim of origin and her Chicana genealogy. But before we begin to explore the narrative chronicle, the themes and meanings, we must first establish like a cosmologist what the philosophy of this universe entails, its totality of parts and even in what way the phenomenon is subject to laws. We must start with the organizing principles of the artist herself, her gaze and her position.

THE INSTRUCTIVE GAZE

As we enter the world of Carmen Lomas Garza's paintings we are stuck by her keen observations. We see, witness, watch, peer, scan and behold through her gaze. The artist is in command of her cosmos through the picture plane. She organizes and arranges so that we see what she wants us to see and what it is she truly wants us to know. Hers is an instructive gaze that directs us to the scene at hand. Through her memory we take part, subtly regulated by her compositions and her lens. We do not encounter the typical male gaze so often referred to in the

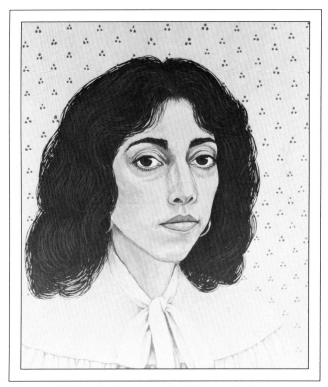

Autoretrato (Self Portrait), 1980, gouache, 8 1/2 x 7 1/2 inches, Collection of the artist

critical discourse of power relations. We do not experience women peripherally as is so customary in the dominating male gaze of Western art. No, this is the female vista that is in view and, even more, made a point of view. Through the instructive gaze of Lomas Garza women assert a locus of control and become central to the action of the painting. Whether killing a chicken in *Para La Cena* (1986) or healing in *Curandera* (1989) or even as the sole character returning our gaze in *Autoretrato* (1980), Lomas Garza's women master their universe. These women occupy the central activities of the paintings, are engaged in labor, teaching, healing, cooking and nurturing. There is no patriarchy positioning the women in these works. Instead we see a feminine lineage of power, nurturance, protection and productivity that is at the same time communal and domestic.

The centralized positioning of these women subverts the traditional sexual politics assigned to women depicted on the margins. Consequently we are directed to "see" these figures in an emancipated stance as Lomas Garza relocates the feminine. We know the artist's own emancipation because these memories are reflective of her own worldview and for the audience are instructive of a liberated domestic space. We recognize in this cosmology an art that is not simply reflective of ideology but rather an art that is constructive of ideology. The instructive gaze, therefore, tells us a new story of the Chicana women or perhaps reminds us of one we had forgotten. It has not been Lomas Garza's intention to speak of her life as a woman, but to speak of her life as a Chicana. The interpenetration of race,

class and gender has given a political significance to her feminine and domestic world.

The instructive gaze has an autobiographical stance as well. Although most often the memories are directly hers, on occasion an event is told to her by someone else in the family. In this way her participant observer role engages us and we see what she has beheld. But even her role in the narrative is directed by her instructive nature. The artist does not appear in her etchings or her paintings until after her frank gaze has been cast at us from her self portrait, *Autoretrato* (1980). It is as if she will not show us her place in this cosmos, will not register herself in the chronicle until she has faced us directly, eye to eye. Then and only then is she free to join in the memory, free to step forward for us in the familiar and familial world of her making. After her self portrait, she first appears to us in her moment of artistic origin. Her gouache painting *Camas para Sueños (Beds for Dreams,* 1989) makes use of a somber palette, a moonlit scene and a remembered vignette of Lomas Garza and her sister Margie lying on the roof of their house. The scene captures a sense of dreams and aspirations. Encouraged by their mother to imagine while she provided for their protection and sustenance, the sisters planned their future. For Lomas Garza it was in this moonlit moment that the adolescent crystallization of her artistic life took place. Like the *loteria tabla*, like the *autoretrato*, *Camas para Sueños* is a beginning, a dedication to all her work to come.

Now we are secure in the instructive gaze, part of an unfolding story created by the artist. Yet the characters and figures are only part of the 'seeing' in Lomas Garza's work.

Her staging and setting contributes to the learning for us. She arranges and composes the events and actions in the homespace, in the community, in the countryside and occasionally in the mythic state. It is in her spatial arrangements and in her temporal powers that we recognize her magic. Zamudio-Taylor has referred to the fascinating and the uncanny as the spellbinding aspect of Lomas Garza's work. It is in this presence of temporal reality magnified in minute details that she does, in fact, cast the spell.

Lomas Garza's capacity to scrutinize and observe springs in part from her sibling caretaking and her own frail physical health. Both conditions often required her to watch from the sidelines. But no matter what the genesis of her observational powers, this artist's eye scans, surveys, records and examines each detail from memory. We are presented with a worldview complete with flora and fauna, time and place. Her accuracy for plants and animals reflects her indigenous sensibility for a natural world in balance and harmony. Whether at midday, at twilight, whether on the porch or in the yard, each scene is scrupulously and lavishly filled for our eyes to behold. Yet as we (re)collect and read the chronicle we see with the lens that the artist directs. Sometimes her gaze pans like a wide-angle camera and on occasion she applies her zoom lens as we are treated to the most intimate and careful rendering of a pair of hands slicing the cactus or in the world of the *Horned Toads A Medio Día* (1987). In this piece we are reminded of the instinctual cycle of food, an animal chain of events that illustrates on a minute level the cosmological setting.

The artistic licence arises when there is a need to present the story in its totality and the artist must manipulate the composition. Perhaps the furniture must be moved about to insure our best view and to provide for the audience the most important information. If the event being remembered occurred between two rooms it must be rearranged in only one space for purposes of readability. Even the gaze itself must be levitated so that we may see into the room or be assisted by a table that is tilted for more visual access. Frequently a stage setting is created by the porch, the yard, the community street and the home. Whatever the setting and the manipulation, it serves the instructive gaze. In some instances, like the devices of memory, we experience condensations, reversals and displacements. In the moment of déjà vu, an eerie sense of repetition occurs in a dream time of our own remembrance.

These decisions and arrangements are like the laws of the cosmology. Time, space and phenomenon are governed by the acts of memory and the values being affirmed. Lomas Garza chooses with care the chronicle at hand and shares with the viewer a cinematic power to affix the gaze, to draw us in and ultimately to focus our knowing, our believing, in the world she cherishes.

THE CHICANO UNIVERSE

The values inherent in the (re)membered experiences of Carmen Lomas Garza give power and resonance to the narrating. Part of the larger cultural reclamation of Chicano art, the *monitos* chronicles have maintained the rich tradition of ballads, tales,

and popular story telling. But, the *monitos* narratives embody a selective process; the editing and organizing of memory that occurs often on a deeper and less conscious level than in the oral tradition. Consequently Lomas Garza's memory is visualized in particular events, moments, practices and gatherings that surface for the artist in an order that does not always appear thematic. The psychic nature of memory knows no real time and releases its treasure house of *recuerdos* (mementos) in an unpredictable temporality. The precise and complete memory comes to the artist yet some time may pass before the painting or etching can be completed. The importance and power of particular events may assert themselves as memories without regard to sequence. Consequently, Lomas Garza's work does not always appear as a series. Nonetheless when we look across the body of her work from drawings, lithographs, etchings, and aquatints to gouache paintings we see the emergence of a universe of Chicano values. The persistence of particular phenomenon creates an order to this universe. Like the staging and consistency of figuration in the formal elements of the works we see a consistent focus on certain themes. When approaching works through this universe of meaning particular groupings reveal themselves: Healing and Recovery, Family Nurturance, Traditional Ceremonies, Transformative Adolescence, and Allegorical Stance.

Healing and Recovery

In order to reference the events of healing that are narrated in the works of Carmen Lomas Garza we must consider the Chicano belief system. The ritual of the healing tradition so precisely detailed in Lomas Garza's works is the expression of a worldview that rejects the separation of mind and body. Among Mexicanos it is manifested in the ongoing traditions of *curanderismo* or healing. An understanding of the somatic arises from *curanderismo* where the emotional and psychic state of individual expresses itself in the ills of the body. Such bodily ills are often seen to be a result of the social situation of the individual and include references between the particular psychological stress and the particular part of the body. Jealousy of a sibling for a newborn may demonstrate itself in *empacho* localized in disorders of the stomach. *Susto*, a fright or trauma, may appear in an overall listlessness or apathy. The catalogue of illness and cures also involve healing practices which themselves acknowledge the significance of the social context through forms of a collective cure. This could include members of the family and/or members of the community seen to be essential to the well-being of the person exhibiting the signs of illness. Traditional homeopathic cures might involve the use of herbs, water, eggs, phenomenon extracted from animals, fetishes or talismans and repetitive disciplines such as fasting. The *curandera* or healer would diagnose the individual and might administer a *limpia* or cleansing with smoke, rolling an egg over the body, or removing bad spirits through the ear with burning funnelled paper. Historic healers were often noted for characteristic cures such as Don Pedrito Jarmillo and his water cures which involved drinking various numbers of glasses of water. This Mexican worldview went into the greater Mexican community within the

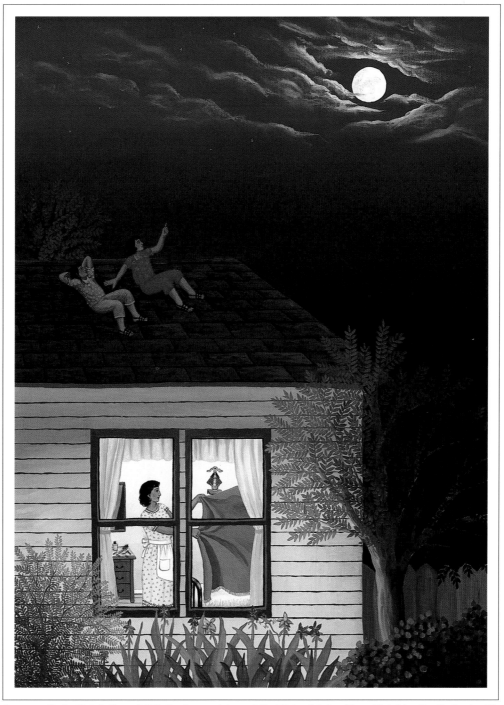

Camas para Sueños (Beds for Dreams), 1989, oil on linen mounted on wood, 32 x 24 inches, Collection of Socorro Maria Pelayo, Esq., San Francisco, CA

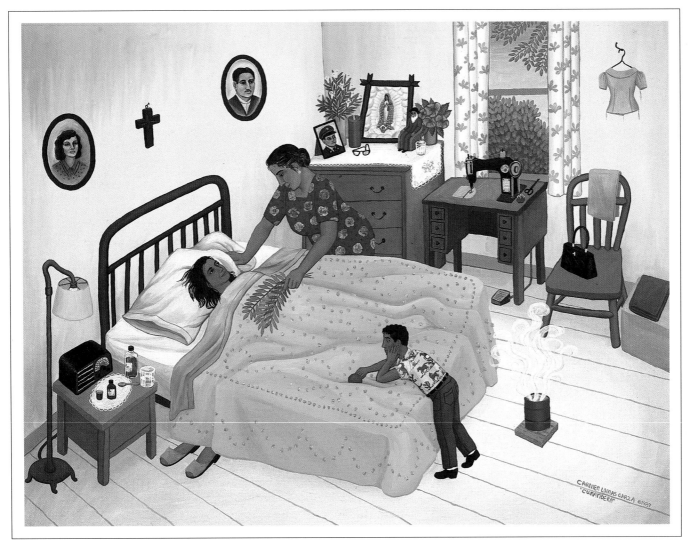

Curandera (Faith Healer), 1989, oil on linen mounted on wood 24 x 32 inches, Collection of The Mexican Museum, San Franciso, CA

U.S. particularly in Texas and along border regions and accounts for the Chicano practices which continue in innovative ways.

It is this foundation and history that gives such familiarity to works such a *Barriendo de Susto (Sweeping Fright Away, 1986), Curandera* (1989), and *Earache Treatment* (1989). The images are complete with elements of the cure: copal incense burning in a can; funnelled paper to heal the *aires (bad air);* the positioning of supportive family members; and the ever present home altars.

Lomas Garza has acknowledged that there is an importance to the *Curanderas* that is greater than any of the other scenes she has chosen to depict. Perhaps what we experience in these works is a collective curing of personal and community ills. It is not coincidental that her earliest etchings following the *Loteria Tablas* and *Jardín* were narrative of the healing tradition. In keeping with the acts of self recovery, the healing images carry out a cure that is beyond the borders of the print or painting. This is a cure for oppression, racism, humiliation and loss. These healers are *Chicana curanderas* who clean away with their brooms and smoke the marks of discrimination and return the body and mind to a wholeness.

For the artist herself the healing memories record events in her family life; adolescent *limpias* to drive out the difficult behaviors of her sister, the sense of well-being so elusive to her own frail health and the need for spiritual cures in moments of distress. The faith healer, Don Pedrito Jaramillo, in particular, was a significant figure in her South Texas community. In keeping with his miraculous cures, Lomas Garza has honored Don Pedrito in etching and altar works and in so doing extends the connection between healing and ceremony.

Traditional Ceremonies

It is in the link between healing and ceremony that the tradition of home altars and Day of the Dead rest. The phenomenon of the home altar in particular affirms a ceremonial life. Established through continuities of spiritual belief, pre-Hispanic in nature, the family altar functions for women as a counterpoint to male dominated rituals within Catholicism. Often located in bedrooms, the home altar locates family history and cultural belief systems. Arrangements of bric-a-brac, memorabilia, devotional icons and decorative elements are created by women who exercise a familial aesthetic. Certain formal and continuing elements include saints, flowers (plastic, dried, natural and synthetic), family photos, mementos, historic objects (military medals, flags, etc), candles and offerings. Characterized by accumulation, display, and abundance, the altars allow a commingling of history, faith and the personal. Formal structures often seen are *nichos* or niche shelves, *retablo* or box-like containers highlighting special icons, and innovative uses of Christmas lights, reflective materials, and miniaturization.

As an extension of this sacred home space, the front yard shrine or *capilla* (little chapel) is a larger scale, more public presentation of the family spiritual aesthetic. *Capilla* elaboration can include cement structures with mosaic mirror decoration, makeshift use of tires, garden statuary, fountains, lighting and plastic flowers. In both the home altar and *capilla,* the transfiguration relies on an almost organic accruing of found objects and differences in scale which imply lived history over time.

For many Chicanas the development of the home shrine is the focus for the refinement of domestic skills such as embroidery, crochet, flowermaking, paper cutting and hand paintings. The spaces of home altar and yard shrine provided for the practice of spirituality. In these spaces faithful prayer and devotion to patron saints and deities extended the relationship of the personal and divine. States of mentality are reached through supplication for divine intervention which produce the traditional *ex-voto* paintings (religious narratives painted on tin) and *milagros* or amulets. The significance of religious imagery in the development of Chicano popular experience cannot be underestimated. Throughout regions of the Southwest, the everyday practice associated with home altars and the Catholic church, includes images of saints, uses of *milagros,* amulets, plaster statuary and front yard shrines of the *Virgin de Guadalupe, Virgin de San Juan de Los Lagos, Santo Niño de Atoche,* and the Sacred Heart of Christ.

For Carmen Lomas Garza this spiritual tradition was a familial part of life. Once again, Lomas Garza's mother facilitated her world of cultural knowledge by the maintenance of the home altar. Yet, as was characteristic of the partnership of her parents, the construction of the family altar space was crafted by her father. His specialized carpentry allowed the family to use the home altar to serve as a protective area for small objects. Small drawers hidden under the altar enclosure stored significant familial papers to be safeguarded. Here, in this powerful site, family photos, the icons of importance and the artistic decorations marked out a narrative of the celestial and the terrestrial for prayer and mediation.

So for Lomas Garza, the chronicling of the home altars in her cultural narratives was an expression of a deeply held worldview and a lived experience. The references to this experience often occur in the staging of the healing activities and family gatherings. The recording of the home altars is a major device in establishing domestic space within the picture plane. On the dresser, on the wall, in corners of the room, the home altar is presented with images of the Virgin, candle and memorabilia. But, Lomas Garza has not been satisfied to articulate the healing and ceremonial memory only in two-dimensional works. She has moved them into mixed-media installations. Her ongoing homage to Don Pedrito Jaramillo makes use of many of the techniques associated with altars including *papel picado,* or paper cutting and *retablo* or ex-voto painting on copper.

Devotional practices are also the potent subject matter of a large-scale painting, *El Milagro* (1987). Here a miraculous apparition on a water tank draws the faithful and Lomas Garza herself as a child. The painting is an evocation of a magical setting, a moment when the community joins in collective and faithful wonderment.

Another aspect of traditional ceremony evident in the works of Carmen Lomas Garza has been *Dia de Los Muertos* or the Day of the Dead celebration. A celebration with Pre-Hispanic and colonial roots, *Dia de Los Muertos* extends Mexican beliefs in regard to the afterlife. The Mexican ritual home altar or *ofrenda,* which welcomes the visiting souls, is central to the recognition of life's ongoing relationship to death. The aesthetic presentation of food offerings, natural phenomena, family *recuerdos,* folk

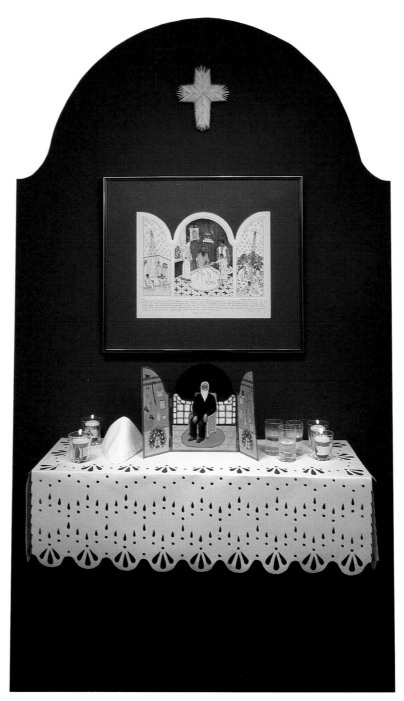

Don Pedrito Jaramillo, 1976-1991, oil on copper (triptych) and mixed media, 84 x 42 x 18 inches, Collection of the artist

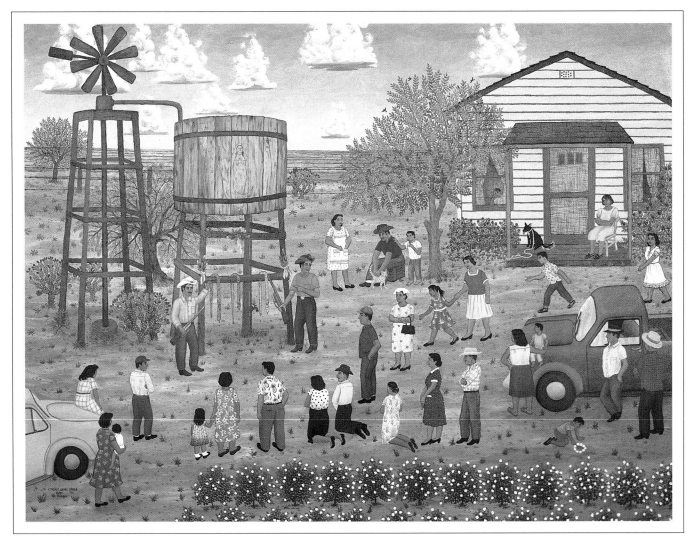

El Milagro (The Miracle), 1987, oil on canvas, 36 x 48 inches, Collection of Nicólas and Christina Hernández Trust, Pasadena, CA

decoration, and toys characterize the *ofrenda*. The splendor of the *ofrendas* is related to the regional tradition, individual wealth, importance of the deceased, and the quality of the yearly harvest. For many families living in poor conditions the death of a young child is a common experience. These children are commemorated in the *altares para los angelitos* or children's altars which are memorialized on November 1, while adults are commemorated on November 2. Special folk art forms and folk aesthetics are an integral part of the celebration. Sugar skulls or *calaveras,* traditional breads, papier maché toys, *papel picado* (cut paper decorations) and ephemeral flower designs are customary on *Dia de los Muertos*. The graveyard decoration includes *arcos* (flower arches), special wax and foil *coronas* (crowns), and shredded *cempazuchitl* flowers, traditional candles and food offerings. These practices of commemoration have grown to a level of folk artistry that has become an established aspect of Mexico's cultural expression.

Dia del los Muertos has become a focus for Chicanos which continues to serve as a vehicle for continuity. Remembering personal and communal *antepasados* (ancestors) strengthened the sense of historic past. With the exception of Mexican/Chicano communities along the borders and in parts of Texas, the celebration of the Day of the Dead was no longer an active part of cultural life. The movement of the 1960's reconnected Chicano communities with this celebration and brought new forms into the contemporary observance. Death and its relationship to life was all-the-more relevant for Chicanos growing up in poverty and exploitation. The dualities were not simply a neo-indigenous reflection of the coping with everyday reality in *barrio* life. True to its origins of ancestor worship, community healing and spiritual discourse, the new genre of *muertos* artistry among Chicanos operates at many levels. Like acts of resistance, the ceremonial reveals what was true and real. In *Dia de los Muertos,* art empowers to indict the poverty of society in the presentation of cultural memory. The commemoration through *ofrendas* and *homenajes* (homages) to departed family members, community leaders and historical figures has become a collective opportunity for artists and community to work together arranging altars, presenting *ceremonias* and processionals in urban as well as rural settings.

In the regional development of this *Dia de los Muertos* tradition, practices have been carried by artist and artisans alike from community to community. Carmen Lomas Garza has been a historic conduit in the spread of Chicano *muertitos* art through her knowledge of tradition and *artesanias* (crafts). She occupies a unique role among artists in her contribution to the Chicano celebration of Day of the Dead. Her transmission of Texas regional artistry to San Francisco's Bay Area has been a major development in the Chicano national celebration of *Dia de los Muertos.* In her *Ofrendo Para Antonio Lomas* (1988-1991), the artist has continually expanded the large-scale *papel picado* technique. The *ofrenda* presents aspects of Antonio Lomas' life and even makes reference to her first etching, *Jardín* (1972), which depicted his agrarian life. A loving sense of *recuerdo* empowers this *homenaje* to her grandfather.

Lomas Garza's style of altar making has also included painted box *retablos*, miniaturization and the development of

her own *muertos* skulls. Beginning with *papel picado calaveras;* Lomas Garza has gone on to create her own papier maché skulls with special decorative detailing that she administers with a cake decorator. But beyond the *artesanias* of her *Dia de los Muertos* work, Lomas Garza has maintained the tradition of respect and remembrance of one's dead. Whether in print, painting or *altares*, the artist has created a chronicle of memory and a cosmology of Chicano values. This dual approach centralizes an ancestry that symbolizes the cycle of life and death. Her *muertitos* work is part of Chicano art focused on the historic dead. Her concern with Pre-Columbian life is part of this redemptive stance as she links past and present.

In traditional ceremonies the personal attests to the power of the family. A thematic structure found in the work of Lomas Garza has been this family ceremony. For a generation of Chicanos the paintings of Carmen Lomas Garza capture in vignette the telling ceremonies of their own childhood. Who can forget the *posada* processional at Christmas as it links together the members of a community. On the most individual yet collective level the *cumpleaños* party marks the private and familial day of celebration complete with *piñata* festivities. The seasonal traditions of *cascarones* (confetti-filled Easter eggs) are part of the remembrance of family work and play so carefully elaborated by the artist. These moments, enumerated and specified with minute gestures are filled with the real and the marvelous. Each event adds to the next as years pass by and we come to know Lomas Garza and her family, their community and their tradition as we recall our own cultural chronicle.

Family Nurturance

Food acts as a connecting aspect of family nurturance in the narrative chronicle of Carmen Lomas Garza. True to her artistic patrimony, Lomas Garza treats the ritual of food preparation with an almost sacred stylization. Lomas Garza can be placed in the tradition of Pre-Columbian sculptures of plants, the colonial *Castas* paintings of cooking and feasting, and in the popular arts depiction of *sandia* (watermelon), *maiz y nopales* (corn and cactus). From her earliest gouache painting of *nopalitos* (food prepared from cactus) and *sandia* the elements of ritual preparation of food has carried with it images of cutting, slicing and piercing. The natural cycle of life and death in the nourishment of the family is ever present in *Para La Cena* and *Conejo (Rabbit)*. It is this duality of the familiar and the sinister that has brought the disquieting edge to Lomas Garza's work. The persistence of her cosmological view of nature delineates the nearness of animals, connected to their human counterparts in the relationships of killing and feeding. At the same time we understand the play of death and sacrifice, sustenance and nurturance in works like *Pedacito de mi Corazón* (1986). Whether it's the heart of the cactus, the heart of the watermelon or the childhood endearment of her *abuela* (grandmother), the "little piece of my heart" occupies multiple meanings. It is perhaps in the works of family nurturance that we are most aware of the shifting text of Lomas Garza's chronicle. We come to understand that these scenes of food preparation and conviviality are more than snapshots of a family together, they are reflections of the ceremonial nature of Chicano family life. The *Tamalada* (1987)

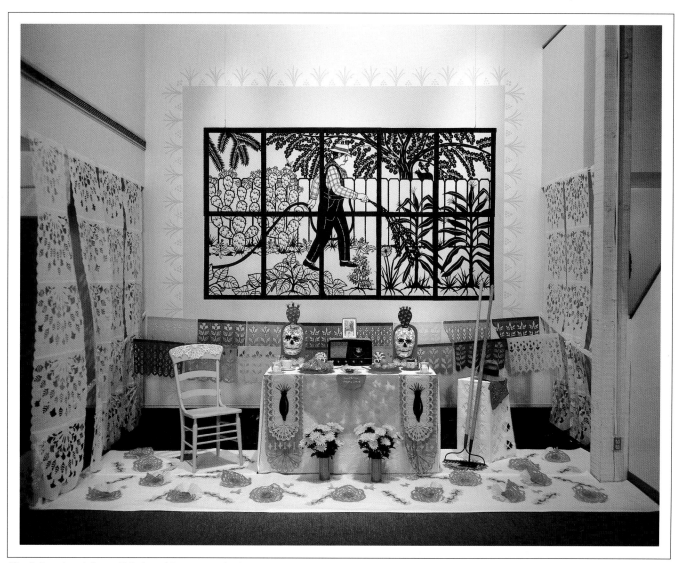

Ofrenda Para Antonio Lomas (Offering to A.L.), 1991, mixed media, 96 x 144 x 120 inches, Collection of the artist

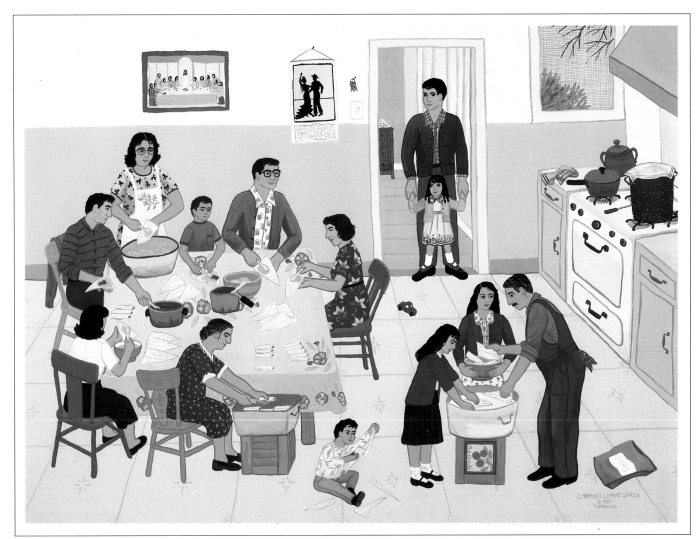

Tamalada (Making Tamales), 1987, gouache, 20 x 27 inches, Collection of Don Ramon's Restaurant, San Francisco, CA

assigns to family members the duties that become the totality of processes that must be assumed in the preparation of this ancient food. Roles are taken, old skills are remembered and distinguishing relationships of the family groups are played out. It is in the commaraderie and security of these domestic tableaus that we experience the signs of danger in the knife or cutting device. Once again Lomas Garza's ever watchful eye alerts us to the potential hazard. Even reminding us that in the security of home the element of reality must always be considered. Yet the nonchalance and calm of the participants seems to nullify the nearness of the risk. Even the masterful coloration in the gouache paintings seems to draw our eyes to the dripping red juice of the *sandia* as we acknowledge the edge of sacrifice. But whatever the impending uneasiness no figure seems to give notice as the moment of nurturance occurs. Young and old are grouped according to their task and are all a part of a cosmological panorama that seems to have lasted forever. In Lomas Garza's world the family setting is the site of nurturance, security and tradition.

Transformative Adolescence

In the chronicling of her memories the artist can indulge her sense of aging. She crystalizes and suspends time for us as she recounts childhood. Grandparents live forever, parents never age and siblings can be recast in younger days in Lomas Garza's narration. We have grown accustomed to this remembered world yet time does somehow move on and we are finally treated to Lomas Garza's adolescence.

Adolescence is an age we all remember for its brutal psychic force, its moments of belonging and moments of rejection. It is a developmental time of identity formation and autonomy that seems largely unfathomable to teenager and parent alike. It is also a time of romance and budding sexuality as the grown-up world begins to cast its spell. In the painting *Polvo y Pelo, El Pleito (Dust and Hair, the Fight,* 1987) we remember with the artist the edges of that adult world, mysterious and compelling. In *Las Pachucas Razor Blade 'do* (1989), through the story of the artist's cousin we are treated to the girlish adolescence of *las pachucas*. The danger asserts itself again in the razor blade hairdo. Yet for the artist, *Las Pachucas Razor Blade 'do* recalls a defiant and protective source in a world of oppression. Lomas Garza remembers *las pachucas* as the only salvation for shy girls, like herself, who could not ward off the racist Anglo aggression. In this respect *Las Pachucas Razor Blade 'do* stands as a sign of resistance and *confianza* (confidence). In this brief glimpse of homegirls we sense the turmoil and painful memories of a segregated and racist world and her chronicling serves again to mark the times of resistance and affirmation.

The Allegorial Stance

As the years have passed, Carmen Lomas Garza has kept her *compromiso* to (re)member for her community. She has affirmed the cultural traditions in her chronicle and she has given order to the cultural cosmology, but other worlds are yet to be described. In a parallel body of work Lomas Garza has begun to explore her

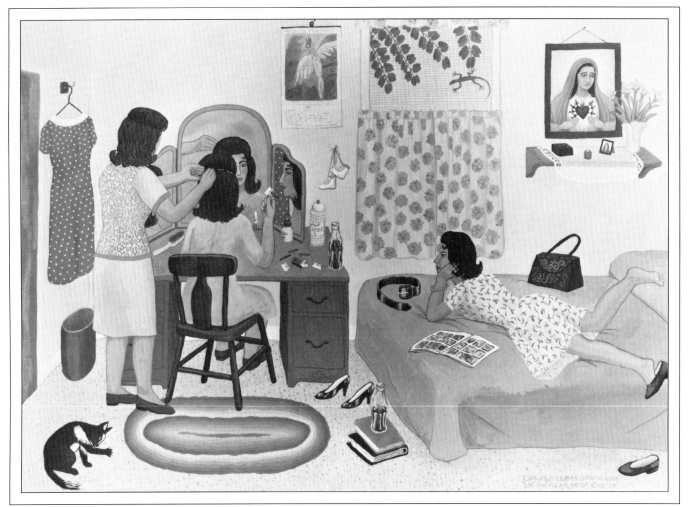

Las Pachucas, Razor Blade 'do, 1989, gouache, 19 1/2 x 27 1/2 inches, Collection of Sonia Saldivar-Hull and Felix Hull, Austin, TX

own allegorical approach to the celestial and terrestrial. In her series *Heaven and Hell* (1989, 1991), we see the device of the diptych where simultaneity and paradox provide the allegory. As always, concerned with values, her worldview begins to play with a narrative beyond memory. The artist gives herself more freedom to develop images from her fantasy. Yet the imagined worlds hold references from the everyday, as heaven provides eternal music and dance; and hell the piteous labor of work never completed. From these beginning allegories we look with anticipation toward a second unfolding universe in parallel with the continuous memories of her family and community.

States of Change

For many artists, stages of development and resolutions in their craft are precipitated by turning points. Lomas Garza transforms her work through specific states of change that are worth noting. A major transition occurred in her historic altar for Don Pedrito Jaramillo (1976-1991) in which she both gave thanks and prayed for help. As she struggled to move into color and painting, Lomas Garza came upon divine inspiration. Following the printing of her Don Pedrito etching, the artist used the copper etching plate by applying paint to it in the tradition of the ex-voto or narrative prayer story. Thus the original print of Don Pedrito inscribed with text was balanced by the painted copper etching as the altar centerpiece. This movement from print to painting becomes linked through the transitional form of the Don Pedrito painting on copper displayed in the mixed media installation. It is as if only the faith healer himself could be the element for this safe artistic transition. Although it would be some time before the gouache paintings with their complex color palettes would reach full development, this state of change will forever remain critical to the artist. Like the traditional *ex-voto* painter in thanks for the divine intervention, Lomas Garza's painting was its own cure.

In the painting *La Llorona (The Crying Woman,* 1989) we witness yet another state of change as the artist constructs a dual world. As Tomas Ybarra Frausto reminds us:

> *The art of Carmen Lomas Garza is one initiation, of uncorrupted first visions where everyday events—the killing of a chicken or the sighting of a star—incite wonderment and reveries. From an innerspace of marvels composed of the palpable and the imagined, the artist molds a compelling dialectic. She gives us a luminous, magical world where the marvelous is encoded in the real* .[2]

In *La Llorona* this encoding of the marvelous and the real is actualized in the story-within-a-story device. Lomas Garza narrates a moment of oral tradition as the grandmother engages in the nighttime telling of *la llorona* myth. Highly symbolic, *La Llorona* is the tale of the ghostly mother whose murderous desperation has left her roaming for eternity in search of her dead children. The benign storytelling moment on the front porch is forever transfigured by the dark river's edge where the image of *La Llorona* and her drowning children come into view. For the first time the mythic and the real occupy the same space at the same time. This allegory of simultaneous dimensions is a

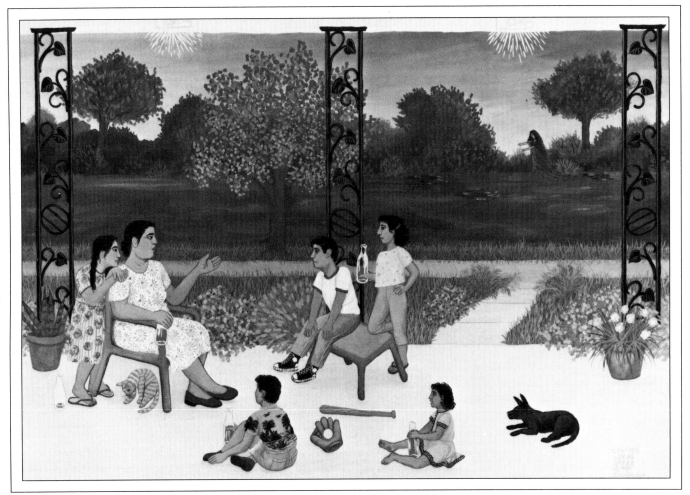

La Llorona (The Crying Woman), 1989, gouache, 18 x 26 inches, Collection of Sonia Saldivar-Hull and Felix Hull, Austin, TX

turning point in the later development of the Heaven and Hell series. It is here that the artist begins a major body of work in allegory and fantasy. Memory joins myth in an emblematic narrative particular to the Chicano world.

CONCLUSION

In her more than twenty-year career Carmen Lomas Garza has presented both historiography and autobiography in her *monitos* paintings. Born of the *loteria tablas,* these doll-like figures have joined the tradition of codices and ex-voto in their direct and sincere narrative. Throughout the chronicling of this personal and collective memory, the artist's intention to serve her community has been realized. The poignant *tableaus* of family gatherings and community traditions have linked the cultural life of countless Chicanos. The cherished practices and harsh struggles of the Chicano people have been affirmed in the cosmology of Lomas Garza. As she has marked the land of her ancestors, she has erased the painful memories of Texas Rangers, segregated schooling and linguistic oppression. The *monitos* speak for us telling stories we all remember, magical, uncanny, and redemptive. This is our chronicle, our cosmology told through the memory of one artist whose heart was dedicated. Thomas Ybarra–Frausto describes this dedication:

> *"In ancient times it was the task of the artist to deify things, to reveal through form, color, and line the inherent diversity in all earthly things, across time and space the moral dimension of the artist has been maintained. Today an aesthetic obligation and major duty of the artist continues to be to produce art with a heartfelt intuition—hacer las cosas con corazón. While the artistic mind explores and depicts the deep structures of social reality, it is the higher task of the heart to intuit and express the boundless horizons of the imagination."* [3]

It is this heartfelt intuition that has marked the works of Carmen Lomas Garza. Consistent and persevering, the artist has (re)collected and (re)membered for us. It is our *Chronos* that has been recorded and we the viewers receive this gift of remembrance in each print and in each painting. But it is perhaps the unspoken, unrecorded, indefinable that gives power to this universe as we await the revelations that lie ahead.

[1] Hooks, Bell; *Yearning "Homeplace"* pg 42 published 1990 by South End Press, Boston, MA

[2] Ybarra-Frausto, Tomas, *Carmen Lomas Garza, The Marvelous/The Real*, pg 10 published by the Mexican Museum 1987. San Francisco, CA

[3] Ybarra-Frausto, Tomas, *Lo Del Corazón*, pg 13, published by the Mexican Museum, 1986 San Francisco, CA

Amalia Mesa-Bains received her Ph.D. from the Wright Institute, Berkeley. She is a nationally known artist working in the altar-installation form. Her scholarship and critcism has focused on cultural identity, spiritual expression and women's development among Latino artists. She is a curriculum specialist and lecturer as well as a community activist in the cultural arts. She is a member of the Board of Directors of the Galería de la Raza in San Francisco and currently serves as Commissioner of Art for the city of San Francisco.

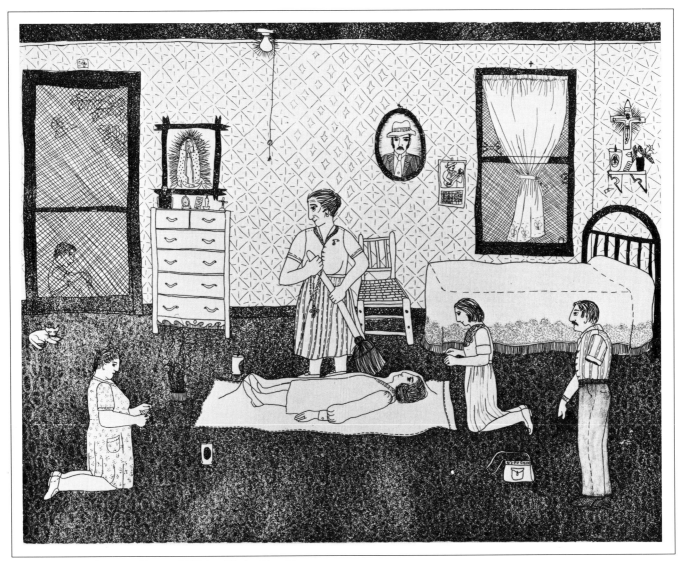

Curandera (Faith Healer), 1974, etching, 14 x 17 1/2 inches, Collection of the artist

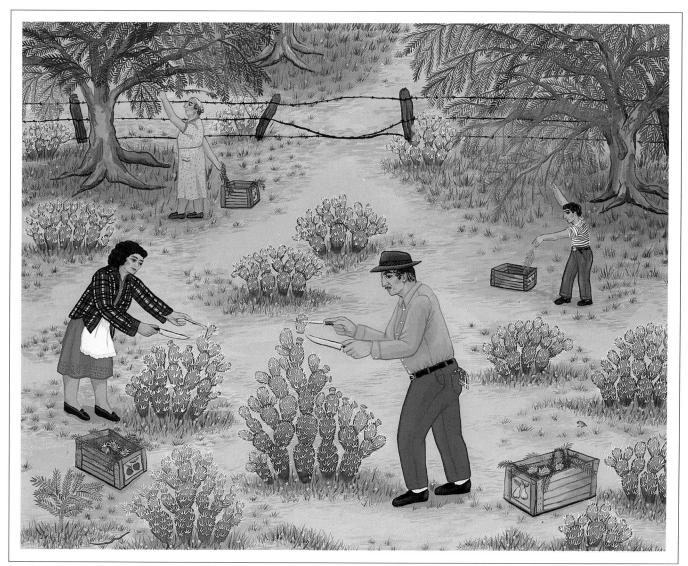

Abuelitos Piscando Nopalitos (Grandparents Cutting Cactus), 1979-80, gouache, 11 x 14 inches, Collection of Richard L. Bains & Amalia Mesa-Bains, San Franciso, CA

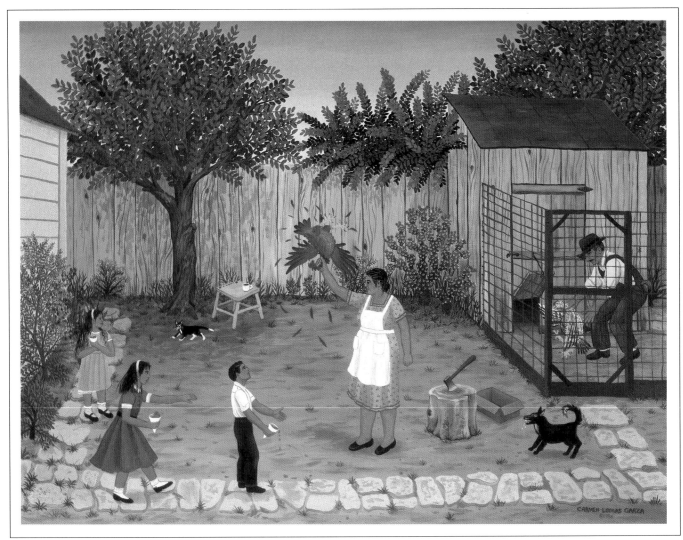

Para la Cena (For Dinner), 1986, oil on linen mounted on wood, 24 x 32 inches, Collection of Calvin Taunton, Los Angeles, CA

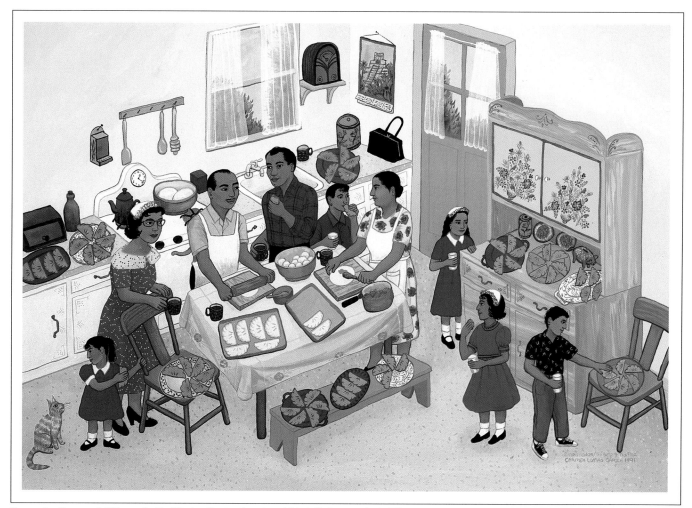

Empanadas (Turnovers), 1991, gouache, 20 x 28 inches, Courtesy the artist and Galería Sin Fronteras, Austin, TX

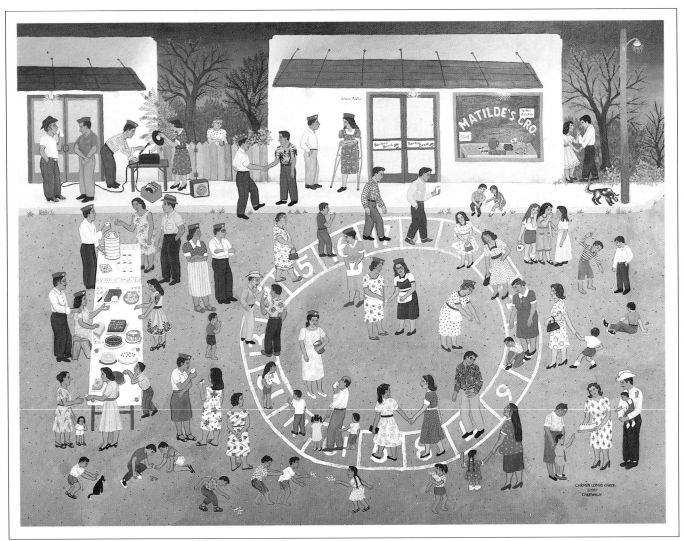

Cakewalk, 1987, acrylic on canvas, 36 x 48 inches, Collection of Paula Maciel Benecke and Norbert Benecke, Soquel, CA

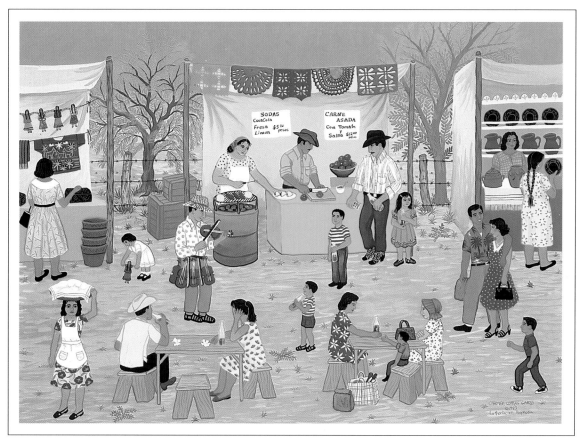

La Feria en Reynosa (The Fair in Reynosa), 1987, gouache, 20 x 28 inches, Collection of Teofila Dane, San Francisco, CA

*Polvo y Pelo, El Pleito (**Dust and Hair, the Fight**)*, 1987, gouache, 20 x 28 inches, Collection of Pamela and Martin Krasney, Sausalito, CA

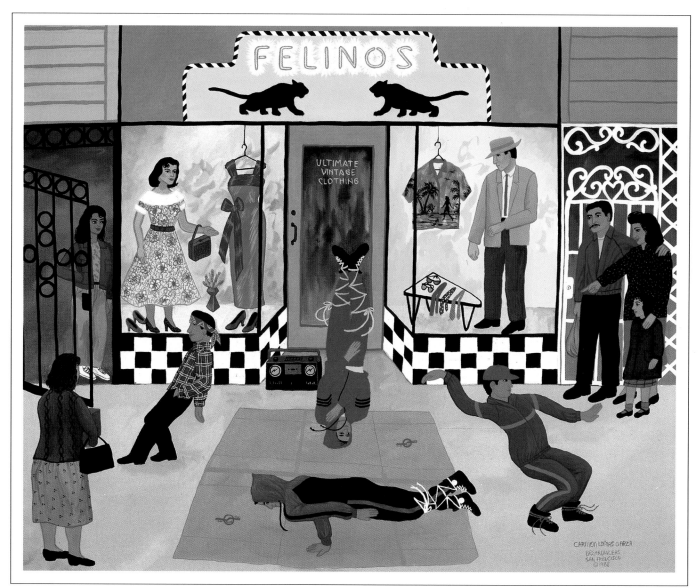

Felino's Breakdancers, 1988, gouache, 20 x 25 inches, Collection of The Oakland Museum, Gift of the Art Guild, Oakland, CA

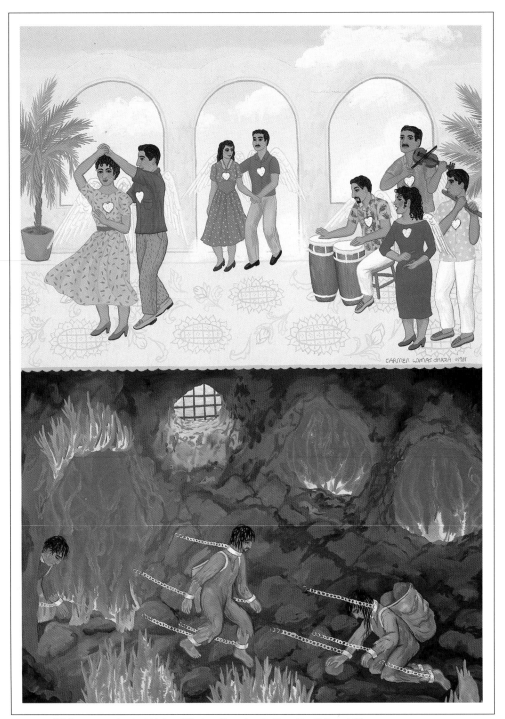

Heaven and Hell, 1989, gouache, 28 x 20 inches, Collection of Jacqueline Markham, West Hollywood, CA

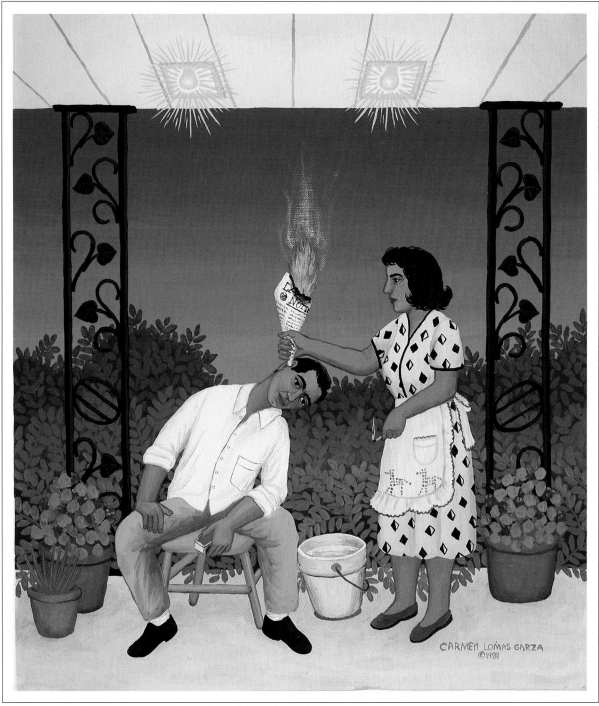

Earache Treatment, 1989, oil on canvas, 17 x 15 inches, Collection of the artist

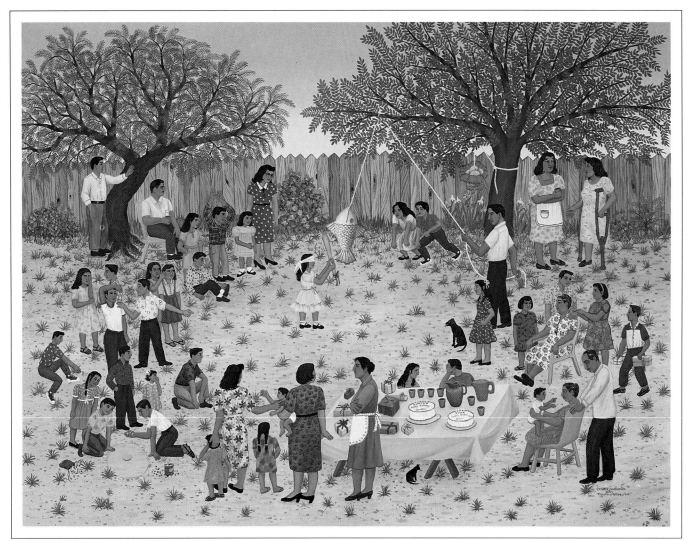

Cumpleaños de Lala y Tudi (Lala's and Tudi's birthday party), 1989, oil on canvas, 36 x 48 inches, Collection of Paula Maciel Benecke and Norbert Benecke, Soquel, CA

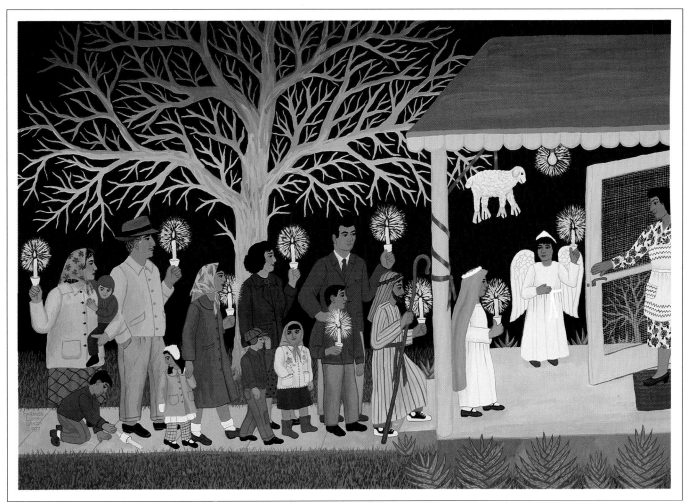

Posada (Inn), 1987, gouache, 20 x 28 inches, Collection of Marina D. Alvarado and Gilbert Mercado, Jr., Los Angeles, CA.

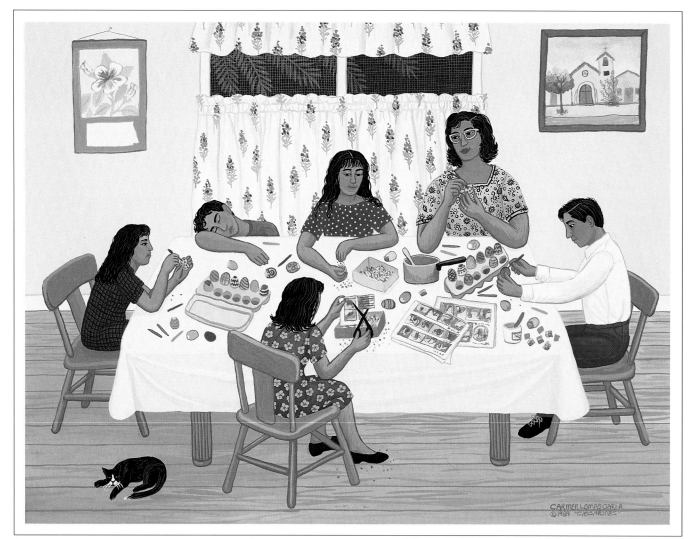

Cascarones (Easter Eggs), 1989, gouache, 15 x 20 inches, Collection of Gilberto Cardenas and Deanna Rodriguez, Austin, TX

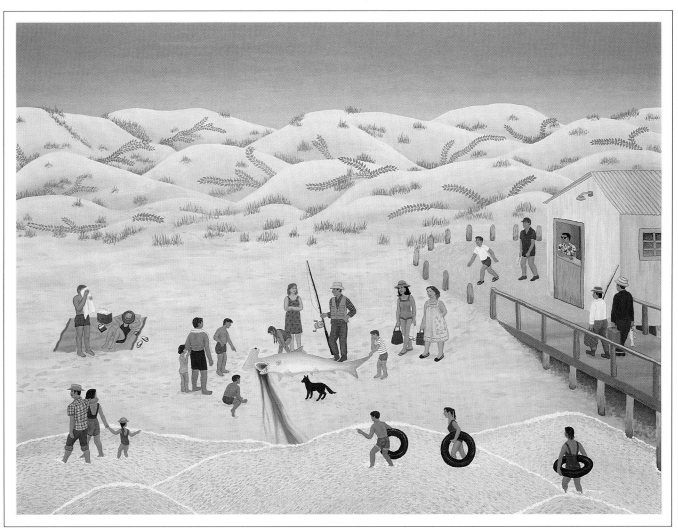

Hammerhead Shark on Padre Island, 1987, oil on canvas, 36 x 48 inches, Collection of the artist

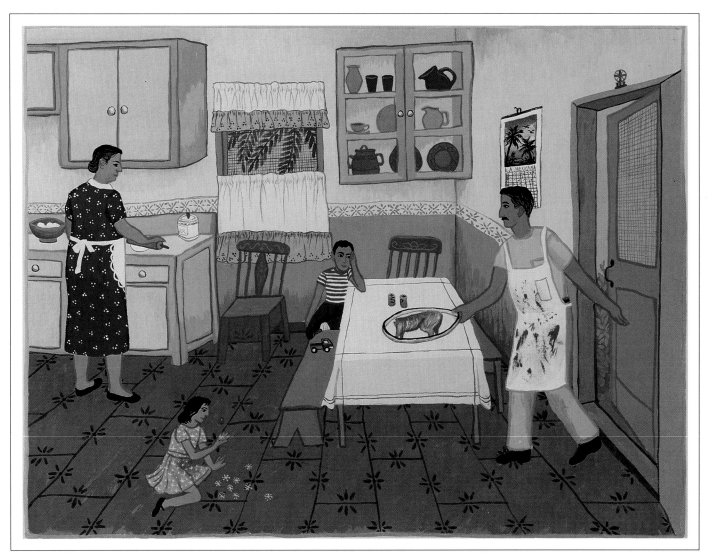

Conejo (Rabbit), 1987, gouache, 11 x 14 inches, Collection of Steven Alvarado and Catalina Guevara Alvarado, Oakland, CA

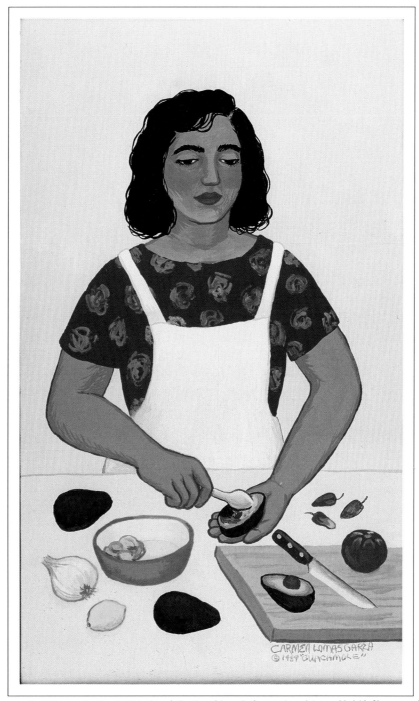

Guacamole, 1989, gouache, 9 x 5 1/2 inches, Collection of Antonia Castañeda and Arturo Madrid, Claremont, CA

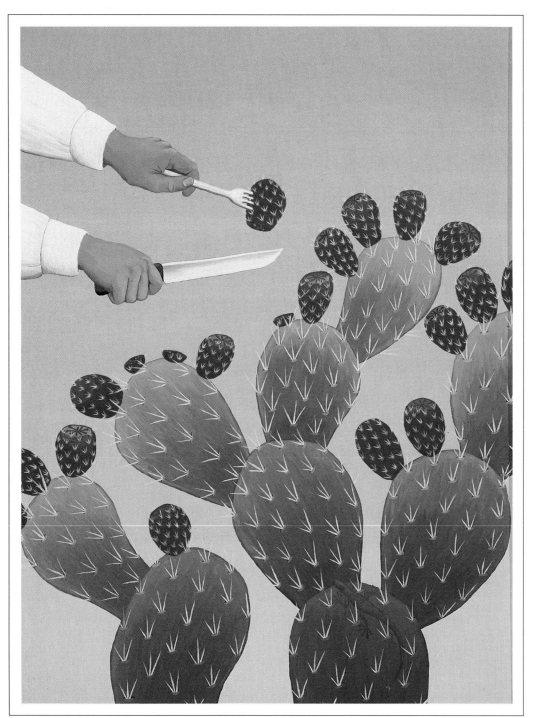

Prickly Pear (A Little Piece of My Heart), 1991, oil and alkyd on wood, 32 x 24 inches, Collection of the artist

BIRTH PLACE AND YEAR: 1948, Kingsville, Texas.

EDUCATION:

Master of Art, San Francisco State University, San Francisco, California, 1980. Master of Education, Juarez-Lincoln/Antioch Graduate School, Austin, Texas, 1973. Bachelor of Science, Texas Arts and Industry University, Kingsville, Texas, (Texas Teacher Certification), 1972.

GRANTS AND FELLOWSHIPS:

1990	California Arts Council Fellowship in Painting.
1987	National Endowment for the Arts Fellowship in Painting.
1986	California Arts Council Artist in Residence Grant. Sponsored by The Mexican Museum.
1984	California Arts Council Artist in Residence Grant. Cosponsored by the Mexican Museum and Real Alternatives Program, San Francisco.
1982	California Arts Council Artist in Residence Grant. Sponsored by Galería de la Raza/Studio 24, San Francisco, California.
1981	National Endowment for the Arts Fellowship in Printmaking.
1979	California Arts Council Artist in Residence Grant. Sponsored by Galería de la Raza/Studio 24.
1967	Texas A&I University Art Department Tuition Scholarship.

PRINT PUBLICATION AWARDS:

1991	(untitled color Lithograph), GAPP, Guest Artist in Printmaking Program, Department of Art, College of Fine Art and the Center for Mexican American Studies, University of Texas at Austin. *Heaven and Hell,* (color lithograph), Rutgers Center for Innovative Printmaking, Department of Visual Arts, Mason Gross School of the Arts, Rutgers State University of New Jersey.
1989	*Lessons,* (color lithograph), MALDEF, Mexican American Legal Defense and Educational Fund, Los Angeles, California, (printed at Polygon Press, Oakland, California).
1988	*Las Peleoneras,* (color lithograph), MARS, Movimiento Artistico del Rio Salado, Phoenix, Arizona, (printed at Sette Press, Tempe, Arizona).

PUBLIC COLLECTIONS:

Fresno Unified School District, Fresno, California.
Galería de la Raza/Studio 24, San Francisco, California.
Lang Communications, New York, New York.
McAllen International Museum, McAllen, Texas.
McAllen Memorial Library, McAllen.
Mexican American Library Project, University of Texas Library, Austin, Texas.
Mexican Fine Arts Center Museum, Chicago, Illinois.
Plaza de la Raza, Los Angeles, California.
San Francisco Water Department, City and County of San Francisco.
Shields Library, University of California, Davis, California.
Special Markets, Bank of America, San Francisco.
Texas Women's University, Denton, Texas.
The Mexican Museum, San Francisco.
The Oakland Museum, Oakland, California.

EXHIBITION HISTORY

SOLO EXHIBITIONS:

1992	Smith College Museum of Art, Northampton, Massachusetts.
1991	*Pedacito de mi Corazón,* Laguna Gloria Art Museum, Austin, Texas (traveling exhibition).
	Tradition & Investigation, Galería Nueva (with Roberto Delgado), Los Angeles, California (brochure).
1990	Dexter Hall Gallery, California Polytechnic State University, San Luis Obispo, California.
	Imagenes Familiares, Bank of America, San Francisco, Los Angeles, and Modesto, California.
1989	Galería Sin Fronteras, Austin, Texas.
1988	Primitivo Gallery, San Francisco, California.
	M.A.R.S. Gallery, Movimiento Artistico del Rio Salado, Phoenix, Arizona (brochure).
1987	*Lo Real Maravilloso, The Marvelous/The Real,* The Mexican Museum, San Francisco, California.

1985 *Carmen Lomas Garza, Galería Posada, Sacramento, California.

1981 Bon Marche Gallery, Eastern Washington University, Spokane, Washington.

The Firehouse Gallery, Del Rio Council for the Arts, Del Rio, Texas.

1980 * San Francisco Museum of Modern Art (with Margo Humphrey), San Francisco, California.

1978 Frank C. Smith Fine Arts Center (with Cesar Martinez), Texas A&I University, Kingsville, Texas.

1977 The Mexican Museum, San Francisco, California.

1975 Trinity University, San Antonio, Texas.

1972 Monitos, Estudios Rio Gallery, Mission, Texas.

SELECTED GROUP EXHIBITIONS:

1991 *Her Story, The Oakland Museum, Oakland, California.

Behind the Scenes: The Collaborative Process, BACA, Berkeley Art Center Association, Berkeley, California (brochure).

*Art as a Healing Force, Bolinas Museum, Bolinas, California.

*Tejanos, The University of Texas at San Antonio Art Gallery, San Antonio, Texas.

*Los Artistas Chicanos del Valle de Tejas: Narradores de Mitos y Tradiciones, Centro Cultural, Tijuana, Baja California, Mexico (traveling exhibition).

1990 *C.A.R.A., Chicano Art: Resistance and Affirmation, 1965-1985 Wight Art Gallery, University of California, Los Angeles (traveling exhibition).

*15 Pintores, 3 Escultores Tejanos Artistas Mexicano-Norteamericanos, Instituto Nacional de Bellas Artes, Museo de Arte Alvar y Carmen T. de Carrillo Gil, Mexico, D.F.

Visible Truths: Traditional Sources within the Chicano Esthetic, Galería Posada, Sacramento, California.

*Body/Culture: Chicano Figuration, University Art Gallery, Sonoma State University, Rohnert Park, California (traveling exhibition).

1989 Places in the Sun, Gumps Gallery, San Francisco, California. (brochure).

Ancient Rites / New Perspectives, Día de los Muertos, The Mexican Museum, San Francisco, California.

Affinities, Jamaica Arts Center, Jamaica, New York (poster brochure).

Obras en Papel, The Mexican Museum, San Francisco, California.

*Ceremony of Memory, The Center for Contemporary Arts of Santa Fe, New Mexico (traveling exhibition).

1988 Día de los Muertos, Mexican Fine Arts Center Museum, Chicago, Illinois.

*Cultural Currents, San Diego Museum of Art, California.

*Mano a Mano, Abstraction/Figuration, The Art Museum of Santa Cruz and the Mary Porter Sesnon Gallery, University of California, Santa Cruz (traveling exhibition).

Artists of Texas A&I University, Ben P. Bailey Art Gallery, Texas A&I University, Kingsville, Texas.

*Personal Histories, Through the Flower, Benicia, California.

1987 *Artistas Mexico Americanos de San Francisco, California, Salon de Sortes, Loteria Nacional, Mexico, D.F.

Connections, San Francisco Arts Commission Gallery, San Francisco, California.

*Hispanic Art in the United States: Thirty Contemporary Painters and Sculptors, The Museum of Fine Arts, Houston, Texas and the Corcoran Gallery of Art, Washington, D.C. (traveling exhibition).

1986 Crossing Borders/Chicano Artists, San Jose Museum of Art, San Jose, California.

*Lo Del Corazón, Heartbeat of a Culture. The Mexican Museum, San Francisco, California (traveling exhibition).

Shrines and Altars: Tradition and Innovation, J.M. Kohler Arts Center, Sheboygan, Wisconsin.

*Chicano Expressions, INTAR, Hispanic American Arts Center, New York (traveling exhibition).

*El Barrio: Primer Espacio de la Identidad Cultural, Centro Cultural, Tijuana, Baja California, Mexico.

1985 *¡Mira!, El Museo del Barrio, New York (traveling exhibition).

Woman by Woman, Galería de la Raza/Studio 24, San Francisco (videotape).

Reliquaries, Niches and Shrines, A Day of the Dead Exhibition, The Mexican Museum, San Francisco, California.

14th Annual Día de los Muertos Exhibition, Galería de la Raza / Studio 24, San Francisco, California.

1984 *Alter Ego, de Saisset Museum, Santa Clara University, Santa Clara, California.

*Ofrendas, Galería Posada, Sacramento, California.

Heritage of the New Chicano, Olive Hyde Art Gallery, Fremont, California.

1983 *International Printmaking Invitational, the Art Gallery, California State College, San Bernardino, California.

Spectrum: A view of Mexican American Art, The Mexican Museum, San Francisco, California.

**Personal Reflections,* Galería Posada, Sacramento, California.

1982 *Cajas y Otras Cosas,* Galería de la Raza/Studio 24, San Francisco, California.

**Hispanics USA,* Ralph Winston Gallery, Lehigh University, Bethlehem, Pennsylvania.

**II Bienal del Grabado de America,* Museo Municipal, Maracaibo, Venezuela.

**Art, Religion, and Spirituality,* Helen Euphrat Gallery, DeAnza College, Cupertino, California.

**California Bay Area Contemporary Prints,* Francis McCray Gallery, Western New Mexico University, Silver City.

1981 *Califas,* Mary Porter Sesnon Art Gallery, Porter College, University of California, Santa Cruz, California.

**Quinta Bienal De San Juan del Grabado Latinoamericano,* Instituto de Cultura Puertoriquena, San Juan, Puerto Rico.

**Staying Visible, The Importance of Archives,* Helen Euphrat Gallery, DeAnza College, Cupertino, California.

1980 **Fifth Anniversary Exhibit, Los Primeros Cinco Anos,* The Mexican Museum, San Francisco, California.

**Joan Mondale Selections for 1980-81,* Vice-President Walter Mondale'shouse, Washington, D.C. (traveling exhibition).

**Self Portraits,* Galería de la Raza/Studio 24, San Francisco, California.

Mosaic: A Multicultural Art Exhibition, Memorial Union Art Gallery, University of California, Davis (brochure).

1979 *Regalos III, Gifts and Acquisitions,* The Mexican Museum, San Francisco, California.

8 Artistas de San Francisco: Paintings and Graphics, The Ruben Salazar Library, Sonoma State University, Rohnert Park, California.

¡Que te vaya Pretty Nice!, Xochil Art Center Gallery, Mission, Texas.

**Fire,* Contemporary Arts Museum, Houston, Texas.

1978 **Homage to Frida Kahlo, Día de los Muertos,* Galería de la Raza/Studio 24, San Francisco, California.

Canto Al Pueblo: Dále Gas, Corpus Christi State University, Corpus Christi, Texas.

Reflexiones: A Chicano - Latino Art Exhibit, El Centro Cultural de la Raza, San Diego, California.

1977 **World Print Competition, 1977,* San Francisco Museum of Modern Art (traveling exhibition).

**Ancient Roots/New Visions,* Tucson Museum of Art, Tucson, Arizona.

**Dále Gas: Chicano Art of Texas,* Contemporary Arts Museum, Houston, Texas.

Chicanas de Tejas, Chicano Art Gallery, The Association for the Advancement of Mexican Americans Art Center, Houston, Texas.

1976 *Tejano Artists in Bicentennial America,* Electric Tower Display Gallery, Houston Lighting and Power Company and The Association for the Advancement of Mexican Americans, Houston, Texas (traveling exhibition).

A Chicana Art Show, The Chicana Research & Learning Center, Austin, Texas.

2001: A Group Exhibit of Mixed Media, Galería de la Raza, San Francisco, California.

Día de los Muertos, Galería de la Raza, San Francisco, California.

Other Sources: An American Essay, San Francisco Art Institute, San Francisco, California.

1975 *Los Quemados, Artistas Chicanos,* Instituto Chicano-Tied and Instituto Cultural Mexicano, San Antonio, Texas (brochure).

Los Quemados, Artistas Chicanos, La Casa Chicana, Southern Methodist University, Dallas, Texas.

1972 *Ms, South Texas Artists,* Pan American University Art Gallery, Edinburg, Texas.

Raíces Y Retono: An Exhibition of Pre-Columbian and Contemporary Chicano Art, Juarez - Lincoln Center, St. Edward's University, Austin, Texas.

1971 *Chicano Artists of Texas,* Fort Worth National Bank, Fort Worth, Texas.

1969 *Chicano Art from Texas A&I University,* MAYO, Mexican American Youth Organization, La Lomita Monastery, Mission, Texas.

* Catalogue accompanies this exhibition.

SELECTED BIBLIOGRAPHY

ABOUT THE ARTIST

Alba, Victoria. "Artists with a Mission." *San Francisco Examiner,* San Francisco, California, May 20, 1990, Image Magazine, pp. 22-31.

Albright, Thomas. "Photographs That Go 'Tilt'." *San Francisco Chronicle,* San Francisco, April 23, 1980, Datebook, p. 64.

Armijo, Richard. "Artistic Maneuvers." *Contact/II,* New York, New York, Vol. 6, no. 34/35 (Winter - Spring 1984-85), pp. 6-17.

Army, Mary Montano. "El Arte: Show Catapults Hispanic to Forefront." *New Mexico Magazine,* July 1988, pp. 37-43.

"Arte: Carmen Lomas Garza." *Magazín,* San Antonio, Texas, Vol.1, No. 9 (September 1973), pp. 57-61.

Baker, Kenneth. "Erratic Offerings in Hispanic Exhibits." *San Francisco Chronicle,* March 12, 1989, Review, Art, pp. 14-15.

Baker, Kenneth. "Everyday Miracles in Mexican Museum Show." *San Francisco Chronicle,* December 26, 1987, Datebook, p. C3.

Beardsley , John and Livingston, Jane. *Hispanic Art in the United States: Thirty Contemporary Paintings & Sculptors.* New York: Abbeville Press, 1987 (catalogue).

Bejarano, William. "Utah Chicano forum." *Chismearte,* Los Angeles, California, Vol. 1, no. 1 (Fall 1976), p. 9-10.

Blanc, Giulio V. Preface in *Hispanics U.S.A. 1982.* Bethlehem, Pennsylvania: Lehigh University Art Galleries, 1982 (catalogue).

Bonetti, David. "The Hispanic vision." *San Francisco Examiner,* October 2, 1989. Style, pp. C-1, C-3.

Brookman, Philip and Amy. *Mi Otro Yo - My Other Self.* Bethesda, Maryland, Brookman, P. & A., 1987 (videotape).

Brown, Betty Ann. "A community's self-portrait." New Art Examiner, December 1990, pp. 20-24.

Burkhart, Dorothy. "Artistic egos led to the altar." *San Jose Mercury News,* San Jose, California, April 29, 1984.

Burkhart, Dorothy. "Chicano Pride and Anger Mix at 'Califas'." *San Jose Mercury News,* April 12, 1981, The Tab, p. 34.

Burkhart, Dorothy. "Critic's Choice." *San Jose Mercury News,* November 25, 1987, Arts & Books.

Burkhart, Dorothy. "Joan Mondale art previews in S.F." *San Jose Mercury News,* March 17, 1980, p. 4C.

Burkhart, Dorothy. "Portraits of a Culture." *San Jose Mercury News,* May 6, 1988, pp. 1E, 13E.

Burkhart, Dorothy. "The political and the personal meet in Latino art." *San Jose Mercury News,* August 1, 1986, Weekend, pp. 1D, 17D.

Burnett, Ginny Garrard. "Art and Chicanismo." *The Texas Observer,* May 29, 1987, pp. 28-29.

Cárdenas, Gilberto and Malagamba, Amelia. *Los Artistas Chicanos del Valle de Tejas: Narradores de Mitos y Tradiciones,* Tijuana: Centro Cultural Tijuana, 1991 (catalogue).

Cárdenas de Dwyer, Carlota (editor). *Chicano Voices.* Boston, Massachusetts: Houghton Mifflin Company, 1975.

Castellón, Rolando. Introduction in Mano A Mano, Abstraction/ Figuration. Santa Cruz, California: The Art Museum of Santa Cruz, County and University of California, Santa Cruz, 1988 (catalogue).

Chapa, Olivia Evey. "Entrevista con Carmen Lomas Garza." *Tejidos,* A Bilingual Journal for the Stimulation of Chicano Creativity and Criticism, Austin, Texas, Vol. 3, no. 4 (winter 1976), pp. front cover, 3, 4, 9, 13, 18, 22-45.

Christensen, Judith. "Disparate Influences, Shared Attitudes." *Artweek,* Vol. 19, no. 27 (August 6, 1988), p. 8.

Clark, William. "National Hispanic Show a 'Dazzler'." *Albuquerque Journal,* July 29, 1988, The Arts, pp. C1, C14.

Cohn, Terri. "Stories of an Unspoiled World." *Artweek,* January 16, 1988, p. 5.

Crohn, Jennifer. "What's the Alternative." *The East Bay Guardian,* March, 1991, p. 41.

Crossley, Mimi. "Art: 'Chicanas de Tejas'." *The Houston Post,* Houston, Texas, March 18, 1977, p. 3C.

Crossley, Mimi. "Art: 'Tejano Artists'." *The Houston Post,* August 19, 1976, p. 7BB.

Crossley, Mimi. "Tejano Artists at Houston Lighting & Power Company." *Art in America,* May-June 1977, p. 121.

Dunham, Judith L. "Joan Mondale Selects for Washington." *Artweek,* March 29, 1980.

El Grito, A Journal of Contemporary Mexican-American Thought, Quinto Sol Publications, Berkeley, California, Vol. 4, no. 4 (1971), pp. front cover, 70-73.

El Grito, Vol. 6, no. 1 (1972), p. 92.

El Tecolote Literary Magazine, San Francisco, Vol. 1, no. 1 (April 1980), p. 5.

El Tecolote Literary Magazine, Vol. 2, no. 2 (July 1981), p. 5.

Everts, Connor. Introduction in *Prints 1/500: International Print-making Invitational.* San Bernardino, California: California State College, 1983 (catalogue).

Frankenstein, Alfred. "An Interesting Ride Into the Art of the Third World." *San Francisco Chronicle,* September, 26, 1976, This World Section, p. 37.

Frankenstein, Alfred. "Monotypes and Brilliant Colors." *San Francisco Chronicle,* August 4, 1977. p. 39.

Friedman, Mary Lou. *The Vice President's House.* Washington, D.C.: The Vice President's House, 1980 (catalogue).

Funk, Kathryn. *Personal Histories.* Benicia, California: Through the Flower, 1988 (catalogue).

"Garza Exhibit." *San Francisco Chronicle,* May 4, 1980, Datebook, p. 10.

Goldman, Shifra M., and Ybarra-Frausto, Tomás. *Arte Chicano: A comprehensive Annotated Bibliography of Chicano Art, 1965-81.* Berkeley: Chicano Studies Library Publications Unit, University of California, 1985.

Gordon, Allan M. "A Mosaic of Cultures and Forms" *Artweek,* February 2, 1980.

Gordon, Allan M. and Ybarra-Frausto, Tomás. *Carmen Lomas Garza / Prints and Gouaches, Margo Humphrey / Monotypes,* San Francisco: San Francisco Museum of Modern Art, 1980 (catalogue).

Guerra-Garza, Victor (editor). "Semillas, Carmen Lomas Garza." *Hojas, The First Years,* A Chicano Journal of Education, Graduate School of Education, Juarez Lincoln University, Antioch College, Austin, 1976, pp. 47-51.

Guilbault, Rose. "Channel 7 Salutes Hispanic Achievers." *KGO-TV, Channel 7, CBS,* San Francisco, September 1988, (videotape).

Harper's Magazine, Vol. 275, no. 1648 (September 1987), p. 30.

Hedges, Elaine and Wendt, Ingrid. *In Her Own Image-Women Working in the Arts.* Old Westbury, New York: The Feminist Press, McGraw-Hill book Company, 1980.

Hererra-Sobek, María and Viramontes, Helena María (editors). "Chicana Creativity and Criticism: Charting New Frontiers in American Literature." *The Americas Review,* A Review of Hispanic Literature and Art of the USA, University of Houston, Vol. 15, nos. 3-4 (Fall - Winter 1987), p. 40.

Hess, Elizabeth. "Affinity Group." *The Village Voice,* New York, December, 1988.

Heyman, Therese. *Her Story: Narrative Art by Contemporary California Artists.* Oakland: The Oakland Museum, 1991 (catalogue).

Hilger, Charles. Forward in *Mano A Mano, Abstraction / Figuration.* Santa Cruz: The Art Museum of Santa Cruz County and University of California, Santa Cruz, 1988 (catalogue).

Hurley, Anne. "Galería de la Raza Turns 20." *The San Francisco Bay Guardian,* August 29, 1990, p 47.

Kong, Luis. "En Camino #312, Latino Artists/Artistas Latinos." *KRCB / Channel 22,* Rohnert Park, California, 1989 (videotape).

Kutner, Janet. "Art with roots." *The Dallas Morning News,* Dallas, Texas, February 17, 1990, pp. 1C-2C.

"La Onda Artistica de Carmen Lomas Garza." *Magazín,* Vol. 1, no. 2 (November 1971), pp. 29-36.

Lewis, Valerie. "A Celebration of Family." *San Francisco Chronicle,* July 29, 1990, Review, p. 9.

Lippard, Lucy R. *Mixed Blessings-New Art in a Multicultural America.* New York: Pantheon Books, 1990.

Lippard, Lucy R. "Report from Houston-Texas Red Hots." *Art in America,* July-August 1979, pp. 30-31.

Lopez, Alejandro. "A Ceremony of Memory opens a CCA." *The Santa Fe New Mexican,* Santa Fe, New Mexico, July 7, 1989, Pasatiempo Magazine, pp. 12-13.

Maldonado, Betty. *Hispanic Artists in the United States - The Texas Connection.* Houston: De Colores Productions, 1988, (videotape).

Martinez, Jr., Santos. *Dále Gas: Chicano Art of Texas.* Houston: Contemporary Arts Museum, 1977 (catalogue).

Matthews, Lydia. "Stories History Didn't Tell Us." *Artweek,* February 14, 1991, pp. 1, 15-17.

McBride, Elizabeth. "Hispanic Art in the United States." *Artspace,* Southwestern Contemporary Arts Quarterly, Vol. 2, no. 4 (Fall 1987), pp. 30-34.

McCombie, Mel. "Hispanic exhibition illustrates culture, artistic power." *Austin American - Statesman,* Austin, May 7, 1987, p. G3.

McCombie, Mel. "Surveying the Range." *Artweek,* Vol. 18, no.22 (June 6, 1987), p. 9.

Mejias-Rentas, Antonio. "Piercing Images of Life." *Hispanic Magazine,* April 1988, pp. 34-41.

Mesa-Bains, Amalia. Essay in *Body / Culture: Chicano Figuration.* Rohnert Park: Sonoma State University, 1990 (catalogue).

Mesa-Bains, Amalia. Essay in *CARA, Chicano Art: Resistance and Affirmation.* Los Angeles: Wight Art Gallery, University of California, Los Angeles, 1991 (catalogue).

Mesa-Bains, Amalia. *Ceremony of Memory, New Expressions in Spirituality Among Contemporary Hispanic Artists.* Santa Fe: Center for Contemporary Arts of Santa Fe, 1988 (catalogue).

Mesa-Bains, Amalia. Essay in *Chartle Papers.* Houston: Museum of Fine Arts in Houston, 1987.

Mesa-Bains, Amalia. "Contemporary Chicano & Latino Art." *Visions Art Magazine,* Los Angeles, September 1989.

Mesa-Bains, Amalia. Essay in *El Dia de los Muertos.* New York: Alternative Museum, 1989.

Mesa-Bains, Amalia. Essay in *Lo Del Corazón: Heartbeat of A Culture.* San Francisco: The Mexican Museum, 1986 (catalogue).

Moore, Sylvia (editor). *Yesterday and Tomorrow: California Women Artists.* New York: Midmarch Arts Press, 1989.

Moreno, Jose Adan. "Carmen Lomas Garza: Traditional & Untraditional." *Caminos Magazine,* Los Angeles, Vol. 5, no. 10 (November 1984), pp. 44-45, 53.

Moser, Charlotte. "Barrio to museum." *Houston Chronicle,* August 21, 1977, p. 15.

Ollman, Leah. "Artists Build Shrines to Personal and Cultural Pasts." *Los Angeles Times -San Diego County,* December 14, 1989, Calender pp. 1, 11.

Ollman, Leah. "'Cultural Currents' Sends Message About American Art." *Los Angeles Times -San Diego County,* circa July, 1988, Calender pp. 1, 7.

Quirarte, Jacinto. *¡Mira!* Detroit, Michigan: Hiram Walker, Inc, 1985 (catalogue).

Quirarte, Jacinto. "New Show Overlooks Hispanic Artists' Roots." *The Santa Fe Reporter,* August 3, 1988, p. 21-22 (catalogue).

Quirarte, Jacinto. *15 pintores, 3 escultores Tejanos artistas mexicano-norteamericanos.* México, D.F.: Instituto Nacional de Bellas Artes y Museo de Arte Alvar y Carmen T. De Carrillo Gil, 1990 (catalogue).

Ramirez, Jesus. "Colegio Jacinto Trevino." *La Voz Chicana,* San Juan, Texas, Vol. 2, no. 13 (1970), p. 1, 6.

Rindfleisch, Jan (editor). *Art, Religion, Spirituality.* Cupertino, California: Foothill - DeAnza community College, 1982 (catalogue).

Rindfleisch, Jan. *Staying visible, The Importance of Archives.* Cupertino: Foothill - DeAnza community College, 1981 (catalogue).

Rodríguez, Armando Rafael (editor). *The Gypsy Wagon - un sancocho de cuentos sobre la experencia chicana.* Los Angeles: Aztlan Publications, Creative Series No. 2, University of California, 1974.

Rodríguez, Laura. "Aqui y Ahora / Female Creators: A Profile of Carmen Lomas Garza." *KTVU/Channel 2,* Oakland, 1982 (videotape).

Romo, Tere (Terecita). *Carmen Lomas Garza.* Sacramento, California: Galería Posada, 1985 (catalogue).

Romo, Tere (Terecita). Introduction in *Carmen Lomas Garza, Lo Real Maravilloso: The Marvelous/The Real,* San Francisco: The Mexican Museum,1987 (catalogue).

Romo, Tere (Terecita). Introduction in *Ofrendas.* Sacramento: Galería Posada, 1984 (catalogue).

Romo, Tere (Terecita). Introduction in *Personal Reflections: Masks by Chicano and Native American artists in California.* Sacramento: Galería Posada, 1983 (catalogue).

Rubinstein, Charlotte Streifer. *American Women Artists-from Early Indian Times to the Present.* New York: Avon Books, 1982.

Santiago, Chiori. "Mano a Mano: We Have Come to Excel." *The Museum of California Magazine,* Vol. 12, no. 5 (March/April 1989), pp. back cover, 8-13.

Santiago, Chiori. "The Mexican Museum." *Latin American Art,* Vol. 2, no. 4 (Fall 1990), pp. 95-98.

Sher, Elizabeth. *Carmen Lomas Garza - Pintora de Monitos.* San Francisco: I.V. Studios, 1983 (videotape).

Silverman, Andrea. "¡MIRA!, El Museo del Barrio." *ARTnews,* Vol. 85, no. 5 (May 1986), New York Reviews, pp. 136-137.

Soto, Gary. *A Summer Life,* Hanover: University Press of New England, 1990, (jacket cover).

Stofflet, Mary. *Cultural Currents.* San Diego: San Diego Museum of Art, 1988 (catalogue).

Surls, James. *Fire! - An Exhibition of 100 Texas Artists,* Houston: Contemporary Arts Museum, 1979 (catalogue).

"The cutting edge." *Austin American-Statesman,* September 9, 1989, Section D, Time Out, p. 1.

Tin Tan, San Francisco, Vol. 2, No. 5 (June 1,1977), pp. inside front and back cover.

Valdéz, Armando. *El Calendario Chicano 1975.* Hayward, California: Southwest Network, 1975.

Van Proyen, Mark. "To Touch both Soul and Body." *Artweek,* April 11, 1991, pp.11-12.

Wasserman, Abby. "The Art of Narrative." *The Museum of California Magazine,* Vol. 15, no. 1 (Winter 1991), pp. front cover 24-28.

Woodard, Josef. "Not So Naive After All." *Artweek,* April 14, 1991, pp. 9-10.

Ybarra-Frausto, Tomás. *Carmen Lomas Garza, Lo Real Maravilloso: The Marvelous/The Real,* San Francisco: The Mexican Museum, 1987 (catalogue).

Ybarra-Frausto, Tomás. Essay in *Ceremony of Memory, New Expressions in Spirituality Among Contemporary Hispanic Artists.* Santa Fe: Center for Contemporary Arts of Santa Fe, 1988 (catalogue).

Ybarra-Frausto, Tomás. Introduction in *Chicano Expressions: A New View in American Art.* New York: INTAR Latin American Gallery, 1986 (catalogue).

Ybarra-Frausto, Tomás. Essay in *Lo Del Corazón: Heartbeat of a Culture.* San Francisco: The Mexican Museum, 1986 (catalogue).

Ybarra-Frausto, Tomás. *Ofrendas.* Sacramento: Galería Posada, 1984 (catalogue).

ZYZZYVA, the last word: west coast writers & artists, San Francisco, Vol. 5, no. 1 (Spring 1989), p. 70.

BY THE ARTIST

"Altares, Arte Espiritual del Hogar." *Hojas, The First Years,* 1976, pp. 105-111.

and Mesa-Bains, Amalia and Pinedo, María. *Homenaje A Frida Kahlo.* San Francisco: Galería de la Raza/Studio 24 (catalogue), 1978.

and Montoya, Jose, and Pinedo, María Vita. *What we are...Now.* San Francisco: Galería de la Raza/Studio 24, (n.d.).

Papel Picado/Paper Cutout Techniques. Mesa, Arizona: Xicanindio Arts Coalition, Inc. Publication, 1984.

"Profile." *Intercambios Femeniles,* Vol. 1 no. 2 (Spring/Summer 1984), p. 7.

and Rohmer, Harriet. *Family Pictures - Cuadros de Familia.* San Francisco: Children's Book Press, 1990.

Self-portraits by Chicano and Latino artists. San Francisco: Galería de la Raza, 1980.